Watercolor for the Absolute Beginner

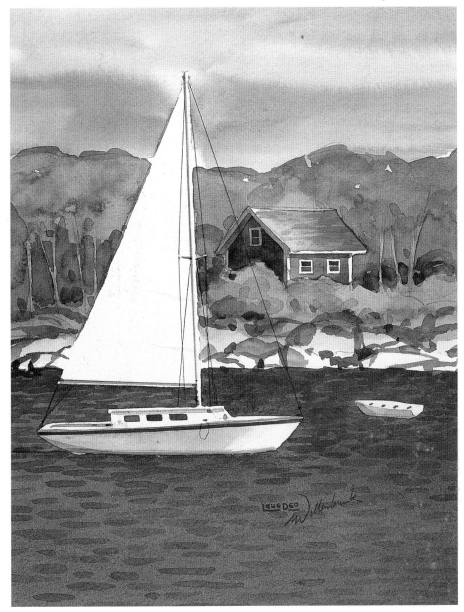

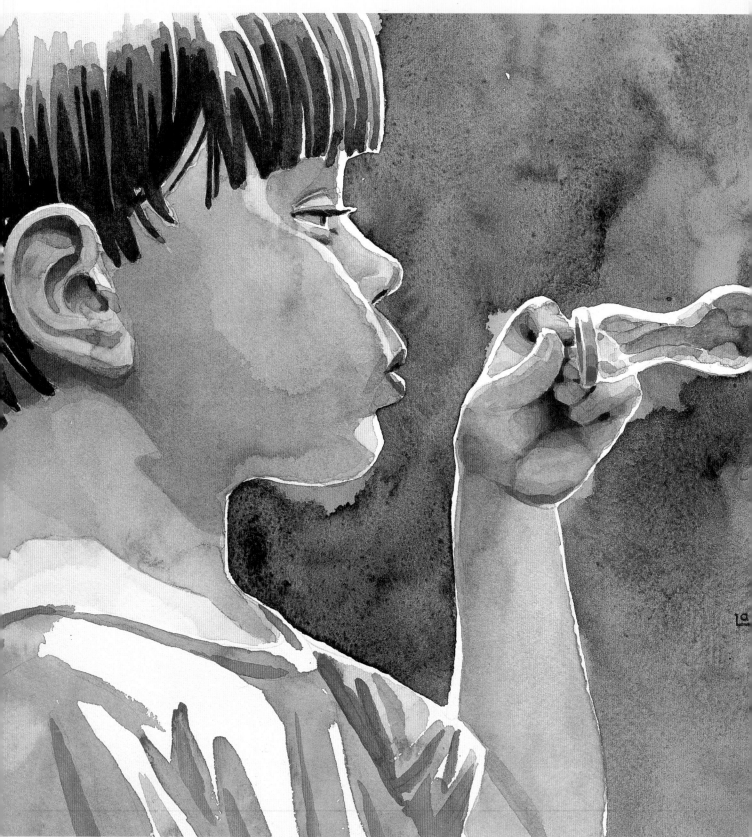

Bubbles
10" x 14" (25cm x 36cm)
140-lb. (300gsm) cold-press watercolor paper

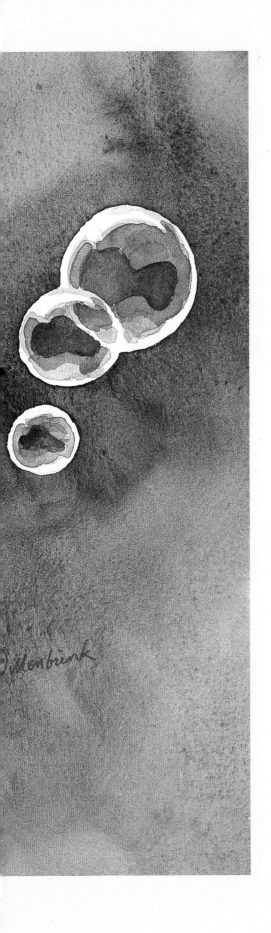

Watercolor
for the
Absolute
Beginner

Mark Willenbrink

written with

Mary Willenbrink

NORTH LIGHT BOOKS
CINCINNATI, OHIO
www.artistsnetwork.com

ABOUT THE AUTHORS

Mark Willenbrink was trained as a commercial artist and worked in advertising and then as a freelance illustrator. Mark currently teaches watercolor classes and is a contributing editor for *Watercolor Magic* magazine.

Mary Willenbrink obtained a master's degree in counseling and worked as a drug and alcohol counselor. Besides her work as a writer, she currently homeschools their two children.

As a husband-and-wife team, Mark and Mary have been writing together for over five years. They reside in Cincinnati, Ohio, with their two children, one cat and a rescued greyhound.

Library of Congress Cataloging-in-Publication Data

Willenbrink, Mark.
 Watercolor for the absolute beginner / Mark Willenbrink written with Mary Willenbrink.—1st ed.
 p. cm.
Includes index.
ISBN 1-58180-341-9 (pbk. : alk. paper)
 1. Watercolor painting—Technique. I. Willenbrink, Mary. II. Title.

ND2420 .W548 2003
751.42'2—dc21 2003048796

Editor: Amanda Metcalf
Production Editor: Maria Tuttle
Cover Designer: Wendy Dunning
Interior Designer: Angela Wilcox
Production Coordinator: Mark Griffin

Metric Conversion Chart

TO CONVERT	TO	MULTIPLY BY
Inches	Centimeters	2.54
Centimeters	Inches	0.4
Feet	Centimeters	30.5
Centimeters	Feet	0.03
Yards	Meters	0.9
Meters	Yards	1.1
Sq. Inches	Sq. Centimeters	6.45
Sq. Centimeters	Sq. Inches	0.16
Sq. Feet	Sq. Meters	0.09
Sq. Meters	Sq. Feet	10.8
Sq. Yards	Sq. Meters	0.8
Sq. Meters	Sq. Yards	1.2
Pounds	Kilograms	0.45
Kilograms	Pounds	2.2
Ounces	Grams	28.3
Grams	Ounces	0.035

DEDICATION

Laus Deo

Praise to God

ACKNOWLEDGMENTS

We would like to thank those behind the scenes at F&W Publications who have made this all possible: acquisitions editor Rachel Wolf, contracts manager Julia Groh, editorial director Greg Albert, production editor Maria Tuttle, designer Angela Wilcox, production coordinator Mark Griffin and marketing director Howard Cohen. We also would like to add a special thanks to Ann, Maureen and Kelly at *Watercolor Magic* for getting us started and giving us the opportunity to try writing and illustrating as a team. We thank all of you for your time and expertise.

To Amanda Metcalf, our editor, we give our heartfelt thanks for your time, patience, listening skills and expertise. We could not have done this without you! Our relationship is blessed with confidence and peace.

We also would like to thank those who have encouraged us to take the giant step forward to write this book. To Mary's parents, Bud and Grace Patton, for your consistent encouragement to keep on writing. To Mark's parents, Roy and Clare Willenbrink, for your encouragement and support in so many ways. To Mary Helen Wallace for introducing Mark to watercolors. You and your artwork have greatly inspired me and influenced this book. Jean Bouche, thanks for the good times we had painting together and for your influence. To Dorothy Frambes for showing Mark how to apply the fundamentals of art in a practical manner while sparking his creativity. To George Soister for your friendship and expertise in photography. Tom Post, for your constant friendship, honest critiques and encouragement, which have challenged Mark to be a better artist and person. Thanks also to the talented cartoonists and illustrators at the lunch group. Being around all of you has "drawn out" the best in Mark. We would like to thank our children, family and friends who have walked through this time with us. Everyone, you've been so supportive!

Lastly, we acknowledge we could not have done this book without each other, and it is by the Lord's grace that our combined talents were able to be used not only to accomplish this book but also to grow in our marriage at the same time.

Table of Contents

Introduction

You could say that painting with watercolors is like being married. In our marriage we've found that the same things we loved about each other in the beginning drove us crazy later. As we learned more about the "art" of marriage, we learned to appreciate each other's qualities and go with the flow. Painters need to have the same relationship with watercolors. As you grow in your talents, you will be able to embrace the unique spontaneity and joy that watercolors can bring to the artist. Each painting then will become not just a product of the artist but a product of the interaction between the artist and the paint.

We hope you find a joy in watercolors with all their temperamental and lovable qualities the same way we found joy working together to create this book. We wish we could be there with you to support you and encourage you as you paint, but we're confident that you'll grow in your gifts and talents as you progress through this adventure. Just go with the flow, literally!

1 *Gather the Materials*

When you're prepared, sitting down to paint a watercolor is exciting. When you're not prepared, the stop-start feeling of getting up and down to find supplies or go to the store can impede your creative mood, inspiration and focus. This chapter will help you collect the right materials to prepare you for a positive experience whenever you feel inspired to paint.

Paints

I use a variety of paint brands and choose paints mostly for their color, solubility and price. Pigments of the same name can vary from one manufacturer to another. Understanding the following variables will help you determine which paints are best for you.

Grade

The biggest variable of paint is its grade. Watercolor paints are available in two grades, student and professional. Student-grade paints are less expensive, but professional-grade paints may provide more intense color and better solubility.

You may not be able to distinguish between the two at first, but after becoming more familiar with watercolors and how the paint behaves, try different colors and brands to see what appeals to you and suits your style.

Intensity

Intensity, the brightness of a color, describes the difference between brilliant and less vibrant colors.

Solubility

Solubility describes the ability of the paints to blend with water and mix with each other. The better the quality of the paint, the easier it will dissolve and the more evenly it will mix.

Lightfastness

Manufacturers often rate the degree of lightfastness, a paint's resistance to fading over time, on the package.

Packaging

I use tubes of paint instead of dry cakes or half pans. You must add water to cakes to make them workable, and the already soluble paint from a tube is easier to work with. If you'll be painting only occasionally, use 8ml or 10ml tubes. Larger volumes may be more economical, but the paint might dry out before you finish them.

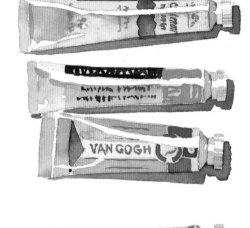
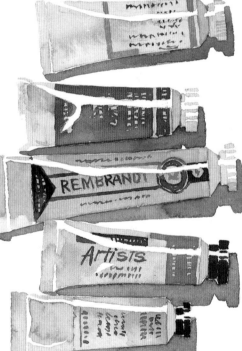

How They Differ

grade
intensity
solubility
lightfastness
packaging

student-grade professional-grade

Different Grades

Examine the difference between these two grades of cadmium yellow. I prefer the more vibrant color of the professional-grade paint, even though it costs more than the student-grade paint. Experiment to find the paints that work best for you. You might like different colors in different grades.

Common Paints

Winsor & Newton, Cotman, Grumbacher Academy and Van Gogh student-grade paints are pictured at top. Winsor & Newton, Grumbacher, Rembrandt, Daler Rowney and Sennelier professional-grade paints are pictured above. Other brands include Da Vinci, Holbein, Schmincke, Lukas, Maimeriblue, BlockX, Old Holland, Daniel Smith and American Journey.

Palettes

Use a palette to hold and mix your paint. Your palette should have a flat, white surface with low sides. Small palettes are easier to carry, but big ones are better for mixing lots of paint. You'll also need a cover to keep dust and dirt off the palette and paints, especially when traveling. If you have an airtight cover, let your paints dry out before covering them to avoid mildew. If your cover isn't airtight, remember to carry your palette flat so wet paint won't spill. When you finish a painting, don't clean the palette and throw away good paint. Because watercolors are water soluble, you can add water and reuse them.

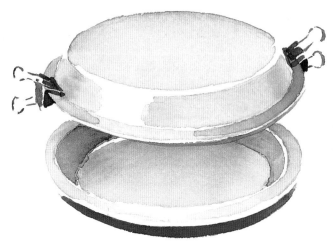

Plastic Plate Palette
You can transform plastic plates into inexpensive palettes. Use one plate to hold paint and the other to mix it. When you're not painting, flip one plate over the other and hold them together with binder clips. This palette is lightweight and inexpensive, so you won't have to worry about carrying heavy supplies or losing expensive ones.

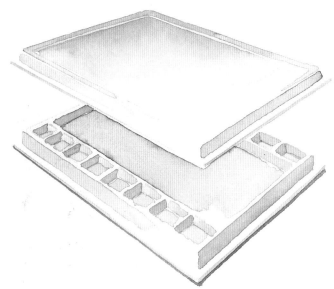

Manufactured Palettes
You can buy plastic palettes that come with paint wells and covers. Get a palette with enough wells to hold all of the colors you want (see page 11) and a surface large enough to mix lots of paint.

How They Differ

cover
shape
size

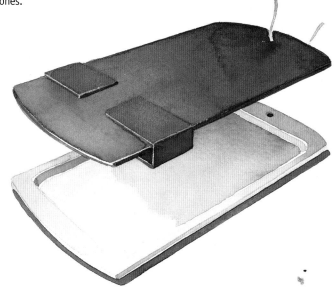

Butcher Tray Palette
A porcelain butcher tray is another option. It's sturdy, and you can place the paint anywhere you choose because there aren't any preformed paint wells. Make sure the surface of the tray is flat before you buy one; many of these trays have convex surfaces that cause paint to run together into the corners. Porcelain butcher's trays don't come with covers, so I fashioned my own with two pieces of heavy cardboard and a piece of string.

To make your own cover, cut one piece of cardboard to the same dimensions as the surface of the palette. Then wrap a strip of cardboard around the lid and palette. Attach the strip to the cardboard lid so it acts as a sleeve to slide the palette into. On the other end of the lid, make a hole and thread a shoestring through to tie the cover and palette together, or secure the lid with a rubber band.

Palette Setups

Each setup shown here progresses in complexity. Most of the colors are available in both student and professional grades. I prefer not to use white or black paint. Instead, I use the white of my paper as the white in my paintings, and I mix my rich darks from other colors. I'll talk more about color practice and theory on pages 30-33.

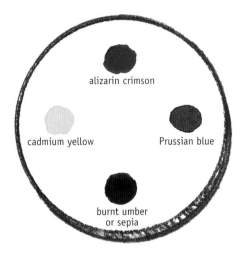

Four-Color Setup
A basic setup uses the three primary colors, red, yellow and blue, and one brown. These colors are available in student and professional grades.

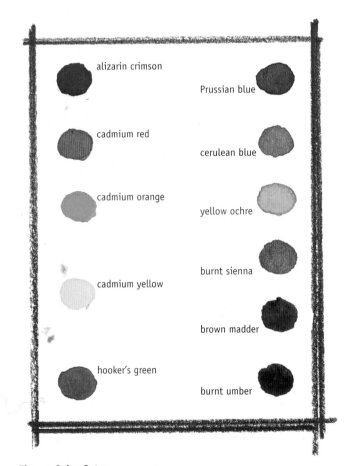

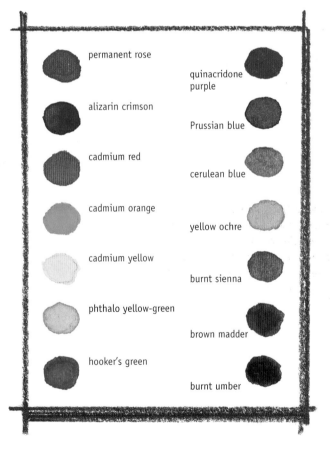

Eleven-Color Setup
This setup for the beginner provides a variety of possible combinations without using too many colors. You'll use this palette for most of the demonstrations in chapter four. All of these colors are available in both grades except for brown madder, which usually is available only in professional grade. I also recommend using professional-grade cadmium yellow.

Fourteen-Color Setup
I usually work with this setup. The additional colors are mostly available only in professional grade. Try this palette after you've gained some experience. It's fairly crowded, so sometimes I use an additional palette or the palette lid for mixing.

Paper

Your painting experience and the end result will differ based on the kind of paper you use. Some papers are harder to work with than others. Many artists use their best paper just for final paintings and other paper for sketches and practice. Consider the following variables when deciding which paper works for your style.

Quality

Student-grade paper generally absorbs paint faster and dries quicker, which makes it harder to work with than higher-grade paper. Professional-grade paper, for the most part, is better for layering and lifting paint and exhibiting the true color and brightness of paints. It's user-friendly, which makes it worth the cost.

Surface Texture

Watercolor paper's texture can be hot-press, cold-press or rough. Hot-press paper is smooth and produces hard edges and interesting watermarks when you apply paint. This kind of paper doesn't work well for gradations of color—a smooth transition from one color to another.

Cold-press paper has a moderate texture and allows smooth color gradations. Some manufacturers refer to cold-press paper, as in "not hot-press."

Rough paper is an even coarser, more textured paper. Like cold-press paper, it allows smooth color gradations, but it offers more extreme textural effects. The rough, pitted surface allows lots of the white of the paper to show through when you paint on dry paper with little water. The texture also adds interest to certain subjects, such as ocean waves.

Content

The content of the paper affects how paint responds to the paper. Most papers are made of natural substances, but some are completely synthetic or made from a combination of natural and synthetic ingredients.

As paper ages, acid can cause it to yellow. To be safe, use 100 percent cotton, acid free, pH neutral paper. Don't assume that pH neutral paper is acid free; the manufacturer may simply have neutralized the acid. Look for "acid-free." I use this paper even for practice paintings because I'm never sure when I'll want to keep one.

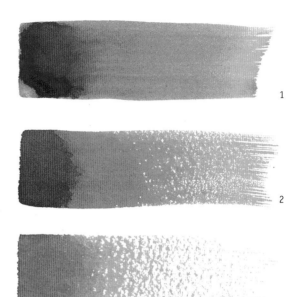

Tooth Translates to Texture
These color swatches show how paint looks when applied to the different kinds of paper: hot-press (1), cold-press (2) and rough (3).

A Paper's Tooth
A paper's coarseness sometimes is referred to as tooth. Hot-press paper (4) is smooth and has very little tooth. Cold-press paper (5) has a moderate tooth. Rough paper (6) has lots of tooth.

Packaging

Watercolor paper comes in individual sheets, watercolor blocks and watercolor pads. Watercolor paper in pad form usually comes in weights of 90-lb. (190gsm) or 140-lb. (300gsm). The paper wrinkles when wet because the sheets are bound on one side only. Watercolor blocks are bound on all four sides. The individual sheets stay in place and wrinkle less. Separate each sheet after painting by running a knife around each side between the top two sheets.

Weight

The heavier the weight, the thicker the paper. Thicker paper wrinkles less after getting wet. Larger pieces of paper wrinkle more than smaller ones.

Common paper weights are 90-lb. (190gsm), 140-lb. (300gsm) and 300-lb. (640gsm). 90-lb. (190gsm) is so thin and wrinkles so easily I find it impractical. Don't use 90-lb. (190gsm) or lighter paper unless it is made from synthetic ingredients.

140-lb. (300gsm) paper can wrinkle, but it's thin enough to see through for tracing drawings and is affordable. Use this paper for any painting 12" x 16" (30cm x 41cm) or smaller.

For larger paintings, use 300-lb. (640gsm) paper. Because of the thickness of this heavy paper, even larger sheets will stay relatively flat when wet. Seeing through it to trace an image is difficult, though. It's also twice the price of 140-lb. (300gsm) paper.

How They Differ

quality
surface texture
content
packaging
weight

For big wet-on-wet paintings, which you'll learn more about in chapter 3, you can wet both sides of a sheet of 300-lb. (640gsm) paper and then mount the paper to a board with Bulldog clips. The thick paper takes longer to dry than lower weights so you'll have more time to work on the painting before the paper starts to dry.

Pads
Pads are bound on one side.

Blocks

Mounting the Paper
It's economical to buy paper in large sheets, then trim them to the size you want. To prevent individual sheets of paper from wrinkling when you apply water, mount the dry paper to a thin, sturdy board, such as waterproof Masonite, plywood or watercolor board. Attach the dry paper on all four sides with 2-inch (51mm) wide sealing tape.

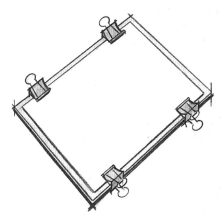

Preventing Wrinkling
You can also mount paper with binder or Bulldog clips. Though easy to use, the clips can get in the way and the paper is more apt to wrinkle than when secured with tape.

Another option is to stretch wet paper by fastening it to a sturdy board with staples or 2-inch (51mm) wide wet application tape. As the paper dries, it pulls or stretches itself into a smooth, flat sheet so the paper is less likely to wrinkle when you apply more water. Stretching may be effective, but I don't find it worth the extra effort.

Brushes

Brushes have either synthetic bristles, natural hairs or a combination of both. I can't tell much difference between them except the price; natural hair brushes cost more.

An artist's supply of brushes should include a range of shapes and sizes. Larger brushes hold more moisture and cover big areas, and smaller brushes work well for detailed work. I recommend the following collection of brushes for beginners.

Round

A good round brush has fine, stiff hairs that come to a nice, straight point and spring back to their original shape.

Bamboo

Big bamboo brushes are inexpensive and hold lots of fluid. They work well for loose, spontaneous painting in big areas, but don't expect to do detail work with them. Besides the large size, the coarse hairs don't always make a point and may seem clumsy to handle.

Flat

Flat brushes look like regular house-painting brushes with wide, flat edges. A flat brush makes wide strokes and leaves clean edges. If you find a flat brush with a round handle, you can twirl the brush as you drag it across the paper to vary the thickness of the stroke.

Hake

Hake (pronounced hockey) brushes are flat, hold lots of fluid and are relatively inexpensive. Use a hake brush for really big washes.

Care and Use

To clean a brush, just swish it back and forth in water until the paint is released from the hairs or bristles. Gently dry it on a clean rag and lay it flat. Once you're done painting, follow the instructions below. When considering quality and cost, don't underestimate the importance of owning good brushes. Cheap brushes can save money but make for a frustrating painting experience.

Storing Brushes
When you're done painting, clean your brushes and place them with the bristles or hairs up in a cup or can.

How They Differ

bristles
shape
size

Storing Large Brushes
Drill a hole in the handles of large flat brushes, and hang them from nails, hooks or wires so the hairs or bristles hang down. If you use a nail, make sure the hole in the handle is wide enough to fit over the head of the nail. If you use a hook, make sure it's deep enough to hold the handle.

Protecting Brushes
Never stand a brush on its hairs, even in a jar of water. The hairs will bend permanently and ruin the brush's point. Also, don't squeeze the hairs to wring them dry or push down hard and scrub while painting. Brush hairs are delicate and the original shape can be bent easily. A good quality brush can last for years if you care for it properly.

Stocking Your Studio

Here's a list of everything you really need to paint in watercolors and make your way through this book. Setting aside time in your schedule to paint really helps you focus on your painting and achieve your goals. Make the most of that time by making sure you have everything you need before you start painting.

Materials List

2B pencil
2H pencil
aluminum foil
brushes
comb
cotton balls
craft knife
foam shapes (cube, sphere and cone)
graphite paper
hair dryer
kneaded eraser
masking tape
mat board
mounting board
onion bag
paints
palette
pencil sharpener
plastic wrap
Plexiglas book holder
rag
rubbing alcohol
salt
sealing tape
sewing gauge
sketch paper
sponge
spray bottle
straight edge
toothbrush
tracing paper
watercolor paper
water container
white latex house paint

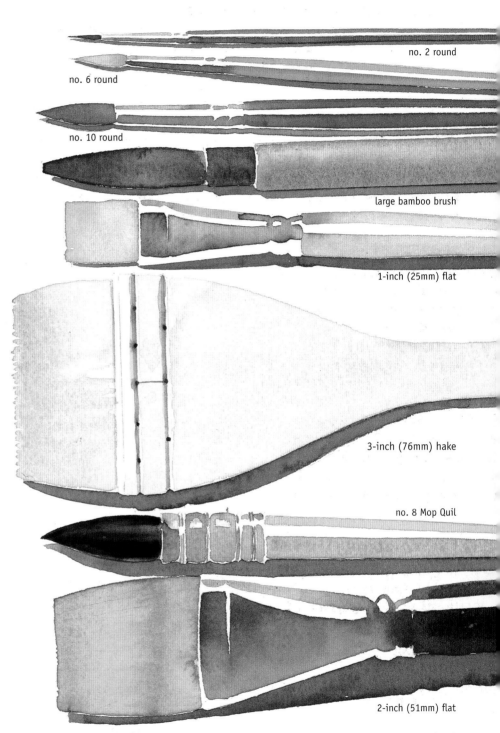

no. 2 round
no. 6 round
no. 10 round
large bamboo brush
1-inch (25mm) flat
3-inch (76mm) hake
no. 8 Mop Quil
2-inch (51mm) flat

Standard Brushes

These are all the brushes you need to paint just about anything. In addition to the types of brushes mentioned on page 14, I also like Mop Quil brushes. They combine the precise qualities of round brushes with the capacity of bamboo brushes. The hairs are not springy, but they can make a nice point. These brushes require an investment, but they're a lot of fun to paint with.

Painting in Your Studio

This is how I set up to paint in my studio. With all of these materials within reach, I'll have a productive painting session.

I cut down a gallon jug to use as a water container. It holds lots of water and has a handle and clear sides, which make it easy to see the water inside. Dry your brushes with a soft, absorbent, 100 percent cotton rag free of lint and dirt. Flannel works well. Make sure you use a light-colored cloth so you can tell if it's dirty. Fill a spray bottle with water for cleaning the palette and moistening your paints.

Use a 2B pencil to draw the basic forms of your composition before painting. A softer lead may smear when wetted down, and harder lead pencil is difficult to erase. Keep a pencil sharpener and a soft, gray, kneaded eraser nearby. Other erasers are abrasive and crumble too easily.

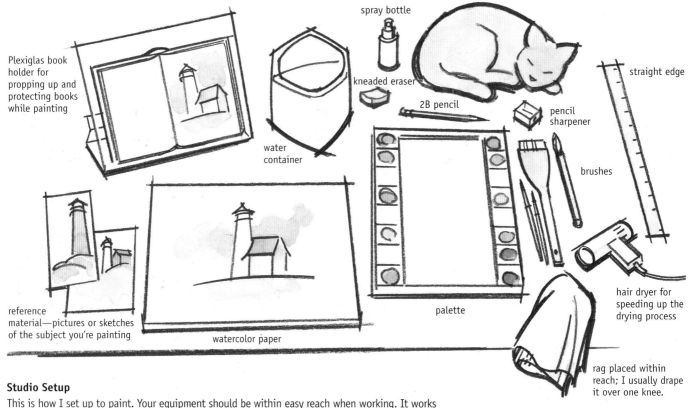

Plexiglas book holder for propping up and protecting books while painting

spray bottle

kneaded eraser

2B pencil

straight edge

pencil sharpener

brushes

water container

palette

hair dryer for speeding up the drying process

reference material—pictures or sketches of the subject you're painting

watercolor paper

rag placed within reach; I usually drape it over one knee.

Studio Setup

This is how I set up to paint. Your equipment should be within easy reach when working. It works best for me to have my tools and palette on the same side as my dominant hand and my water container just above these. I usually sit down while painting, but standing gives you freedom to move, which is especially valuable when painting big. It's important to have adequate lighting, so I make sure I have an overhead light or a desk lamp with a 100-watt bulb. Oh, and if you have a cat, it probably will claim a portion of your work surface. While you may enjoy the company, be careful because pet hair can wind up in your paints.

Painting Outdoors

You don't need an elaborate setup to paint plein air, or outdoors, so I usually pack light. You'll need paints, brushes, a palette, paper, a water container, a 2B pencil, a rag and an eraser, plus the items discussed on this page.

Plein Air Painting Supplies

You may want to bring a painting surface, such as an easel. A French easel has a drawer for storage and extra work space. Bring something to sit on, preferably something that folds up. Make sure it doesn't have arms; they get in the way when you're painting. Buy a brush holder for your smaller brushes and find a way to secure your bigger brushes to protect them. I like to carry a pair of binoculars to get a better look at things in the distance. Many artists carry cameras and sketchbooks so they can take pictures and do quick pencil studies to use as reference later.

Bamboo Brush Holder

Travel can damage the bristles of smaller brushes easily. A bamboo brush holder protects brushes by keeping their hairs straight and allowing wet brushes to dry on the go.

My Toy Box

I use a tackle box as both a seat and a carrying case for my materials. Besides your regular water container, use a separate container with a lid to transport water. I protect my larger brushes by attaching them securely to the tray in my tackle box. First drill a hole in the bottom of the tray. Then run a bolt up through the hole and attach the brush with a nut. You also could attach the brush with a wire or make a cardboard sleeve.

Discussing Materials

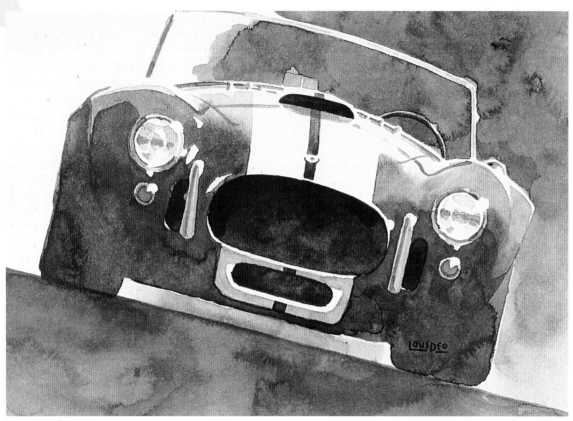

Hot-Press Paper

What makes hot-press watercolor paper so much fun for me is the unique
watermarks that result when the paint interacts with the smooth surface.
This quality may make the paper a bit harder to work with, but as you gain
experience, you'll be able to predict these effects and feel more in control.
Then they can add so much to your artwork. To keep the feel of this paint-
ing loose, I used a large round brush as much as possible. I especially like
the effect of the watermarks on the front of the car, blending the fenders
and tires together.

Cobra
6¼" x 9" (16cm x 23cm)
140-lb. (300gsm) hot-press watercolor paper

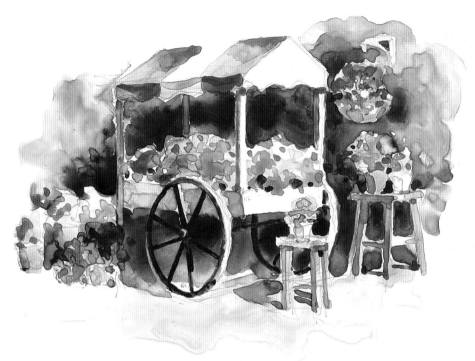

Yupo

Unlike other kinds of watercolor paper, Yupo synthetic paper is basically a really smooth sheet of plastic. The nonabsorbent paper does not wrinkle at all and makes for a very loose painting style with hard paint edges. Because Yupo doesn't absorb paint, you can lift and manipulate color much more easily than on regular watercolor paper. You'll also need to use a large round brush that holds a lot of paint because the paint will want to come back up with the brush rather than lay on the paper. You may need to scrub the surface before you begin to get rid of grease or fingerprints, which can repel paint. Unless the surface is perfectly clean, pai won't adhere to it. Notice how the oil from one of my fingerprints seems to repel paint from th top of the post on the left.

Flower Cart
5" x 7" (13cm x 18cm)
74-lb. (160gsm) Yupo synthetic watercolor paper

Cold-Press Paper

I use Strathmore Aquarius watercolor paper at times when I want a smoother, cold-press paper. It's less prone to wrinkling than other cold-press papers because it's made from a blend of cotton and synthetic fibers. At 80-lb. (170gsm), it's thinner than most watercolor papers I use and easier to see through for tracing. Because the surface is not as soft as others, paint often doesn't seem as lively and removing pencil lines can be difficult.

Sunbathers
6" x 8" (15cm x 20cm)
80-lb. (170gsm) cold-press watercolor paper

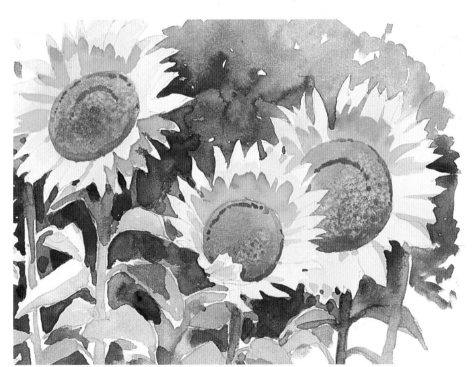

1

2

3

4

Learn the Basics

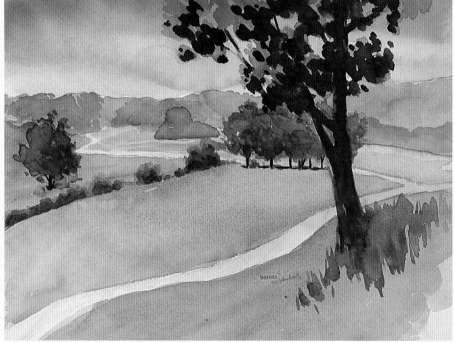

Get back to the basics! Structure. Value. Color. An understanding of all of these components will help you create better compositions and successful paintings.

Structural Drawing

To create a successful painting, you need a solid foundation. Create an accurate drawing of the shapes and elements in a scene before you begin to paint. Structural drawing may seem too scientific or monotonous, but it's essential to the beauty of art. Structural drawings include basic shapes without shading and provide the right starting point for every painting. The basic principles of drawing follow. You may think you can't draw, but everyone can learn.

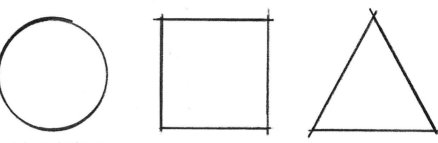

Look for Basic Shapes
Look for basic shapes such as circles, squares, triangles, ovals and rectangles.

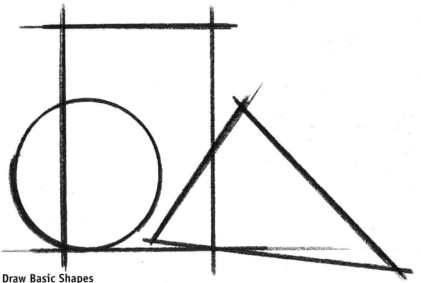

Draw Basic Shapes
Put the big, basic shapes together.

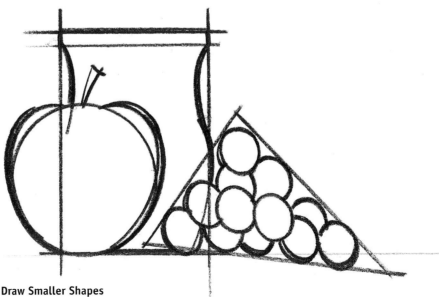

Draw Smaller Shapes
Then draw the smaller shapes, arranging them around the bigger ones. Really observe what you see. Do objects overlap? Your brain tells you an object is round, but does it really look oval? You don't have to draw tons of detail now. Leave the details for the painting process.

Measuring

Making art is a creative process, but that doesn't mean you should ignore the facts. To draw an accurate, believable object or scene, measure to get the proportions right. You can use something as simple as a pencil to measure, compare and align elements.

Keep It Straight
Lock your arm in a straight position, holding the pencil straight, and look at the pencil and the object you're measuring through one eye. Don't bend your arm. You'll end up with inaccurate measurements because you might bend your arm a bit differently each time. By measuring with a straight arm, your scale stays consistent from one measurement to the next.

Measure Image Along Pencil
In this scene, the height of the apple equals the distance between the top of the pencil and the tip of the thumb.

Compare Measurements
Compare the measurement of the height of the apple to the width of the top of the vase. They're about the same. Comparisons like this help produce accurate drawings, especially when objects are arranged at angles.

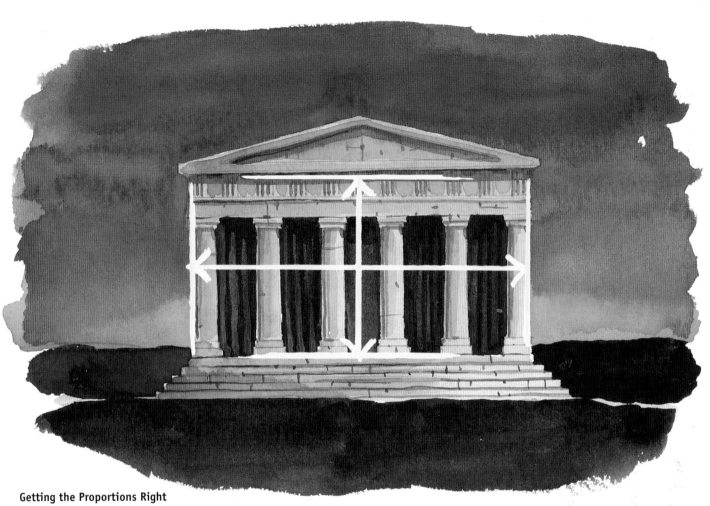

Getting the Proportions Right

Capturing the correct proportions in a painting is the first step in achieving a realistic drawing. The building's width is twice that of the height.

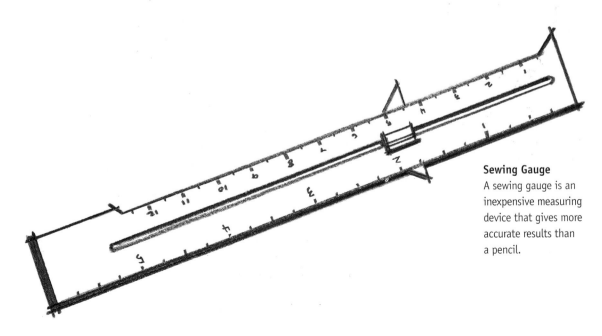

Sewing Gauge

A sewing gauge is an inexpensive measuring device that gives more accurate results than a pencil.

Drawing Linear Perspective

Perspective gives an impression of depth. When viewing an image on a two-dimensional surface, perspective makes the image look three-dimensional. Linear perspective uses lines and varies the relative sizes of objects to create this illusion.

The secret to perspective is finding the horizon. Land and sky meet on a horizon line. Somewhere on this line is at least one vanishing point where parallel lines, such as the rails of a railroad track seem to converge.

One-Point Perspective

One-point perspective is the simplest form of linear perspective, with only one vanishing point. Use one-point perspective when you're looking at an object head on.

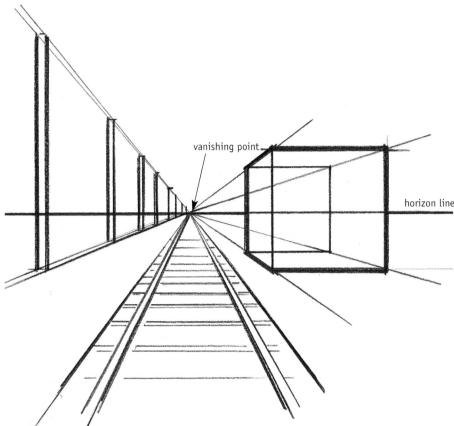

vanishing point

horizon line

Translating From a Three-Dimensional Scene to Two-Dimensional Paper

Observe one-point perspective while looking straight down a set of railroad tracks. Just make sure there's not a train in the way! The parallel tracks converge in the distance at the vanishing point. If a building or other structure is parallel to the tracks in reality, it will share a vanishing point with the tracks. If you extend the structure's line to the horizon, it will meet the others at the vanishing point rather than actually running parallel on the paper. Notice that objects of equal size in reality appear larger the closer they are to the viewer. Drawing things in perspective means drawing them not as they are in reality, but as they look from a certain viewpoint.

Two-Point Perspective

Let's look at the same railroad tracks from the side to get a glimpse of two-point perspective.

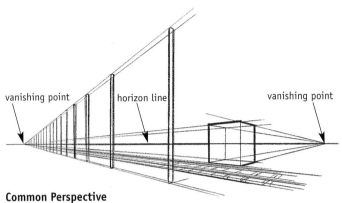

Common Perspective
The most common form of linear perspective is two-point perspective, in which two vanishing points land on the horizon.

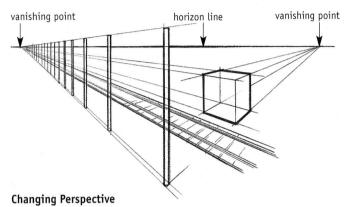

Changing Perspective
By raising the horizon on this two-point perspective scene, the viewer now seems to be looking down on the same scene.

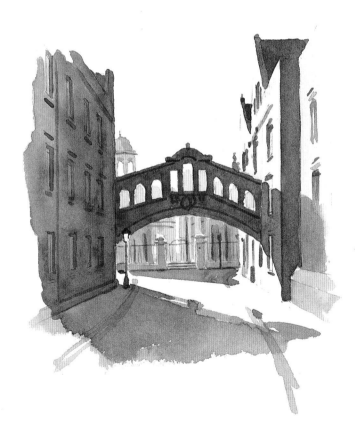

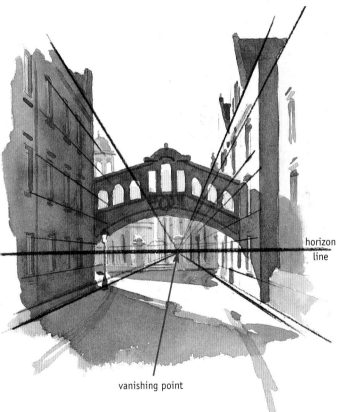

Hidden Vanishing Point
This scene may look simple, but planning ahead and getting factors like perspective right make the scene look accurate and believable. Even though you can't actually see the horizon in this cityscape, you should determine it's location and figure out where your vanishing point will be. Notice that all of the lines—the road, the windows and even the roofs—disappear at the vanishing point.

Understanding Value

Values are the light and dark areas of a scene. Use shading, shadows and contrasting values to provide form and definition for objects and the entire painting.

Shading and Shadows

Observe values on basic shapes to get a better understanding of shading and shadows. Use white foam shapes from your local craft store as models to examine the characteristics of light. You may need to paint the foam a light color to get an opaque surface that reflects light smoothly and accurately.

Pay attention to the direction of the light source—whether it shines from the left or right, above or below, in front of or behind the object. Once you've determined the light source, observe the lightest and darkest areas and the effect of the light source on the object's shadow.

Light

Especially when painting with watercolors, keep the light areas, as well as the shadows in mind. You can always make areas darker with watercolors, but you have to plan the light areas from the very beginning.

Contrast

Contrast is the range of dark and light between values. Value enhances the depth and clarity of a picture. Objects with values that contrast very little appear to be close together. Objects with highly contrasting values appear far apart and more defined. Look at the example right.

The darker the darks in your painting, the lighter the lights will appear. So if you want a light area to look really bright, make the objects around it dark.

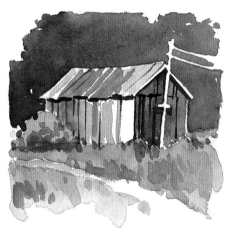

Don't Be Afraid of Contrast
A picture with a low contrast of values (top) may look flat and undefined, as on an overcast day. Beginners tend to be timid with their paints, so they often end up with low-contrast paintings. A picture with a high contrast of values (above) shows depth and definition, as on a sunny day.

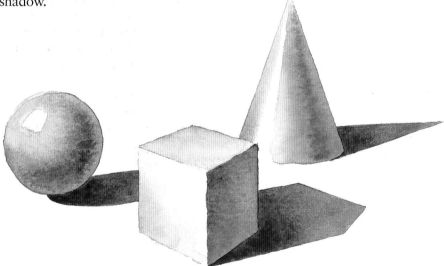

A Range of Values
Values don't just come in white, black and gray. Value also defines the light and dark aspects of color. For instance, the color green may appear as a light value or dark value, each portraying very different moods. In this example, the light source is located to the left and in front of the three objects.

Making a Value Scale

When you've completed this value scale, you'll be able to look through the punched holes to identify the values in a scene and determine the values you'll need for a drawing or painting. You'll need 140-lb. (300gsm) cold-press paper, burnt umber or another dark, neutral color, a no. 10 round brush and water.

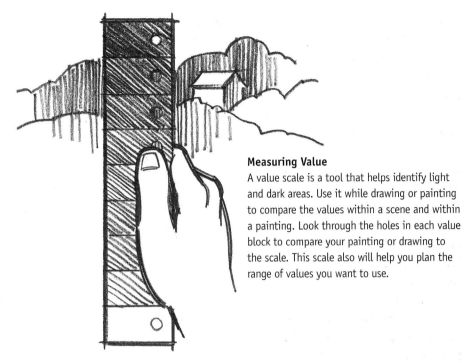

Measuring Value

A value scale is a tool that helps identify light and dark areas. Use it while drawing or painting to compare the values within a scene and within a painting. Look through the holes in each value block to compare your painting or drawing to the scale. This scale also will help you plan the range of values you want to use.

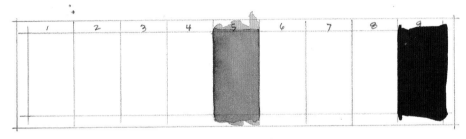

Establish Darkest and Middle Values

Divide a 10-inch (25cm) rectangular piece of 140-lb. (300gsm) cold-press paper into nine equal rectangles, leaving about a ¼-inch (6mm) border around the edges of the paper. Number the rectangles one through nine from left to right on the top border. Paint the ninth rectangle as dark as possible. Then paint in the fifth rectangle with a value about midway between the ninth value and white.

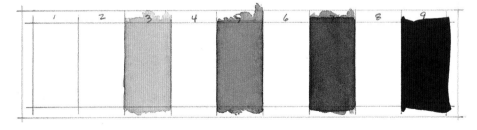

Paint Intermediate Values

Paint the third rectangle with a value between the fifth value and white. Then paint the seventh rectangle with a value between the fifth and ninth values.

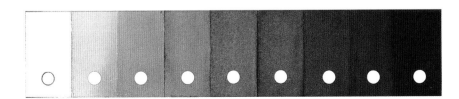

Fill In Values

Paint the even numbered rectangles to make a continuous line of values that gradate from light to dark. Leave the first rectangle white. Trim all four sides and punch holes in each of the rectangles.

Understanding Color Intensity

Think of intensity as the richness or potency of a color—how yellow is a yellow, how blue is a blue—and value as the lightness or darkness of a particular color.

Some colors, such as yellow, can vary in intensity but not much in value. Other colors, such as blue, can vary in both intensity and color.

You can't control intensity like you can control value. Certain colors and paints simply have certain intensities. As you paint more often and experiment with different paints, you'll find the brands and grades of paint that suit your style.

Varying Intensities
The yellow (1) is very intense. The yellow (2) is not intense. Both are light in value. The blue (3) is very intense and has a dark value. The blue (4) is not intense with a light value.

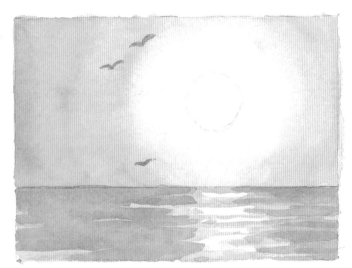
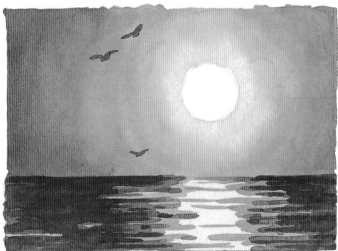

Using Intense Colors
Both paintings use light values of yellow around the sun, but the less intense colors in the scene on the left lose the penetrating effects of the intense colors in the scene on the right.

Painting Atmospheric Perspective

Atmospheric perspective, also referred to as aerial perspective, is the use of color and value to express depth. Objects close to the viewer—in the foreground—have well-defined shapes, contrasting values and intense colors. Objects in the distance aren't as clearly defined and have more neutral values and dull, blue-gray colors.

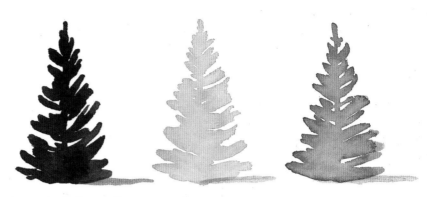

Atmospheric Perspective
The trees show depth with atmospheric perspective but without linear perspective. Only value and color indicate depth. The darkest, most intense tree appears closest to the foreground.

Linear Perspective
The trees show depth with linear perspective but without atmospheric perspective. Size and overlapping objects indicate depth.

Combining Both Forms of Perspective
These trees show depth through both principles, creating the most realistic and appealing scene.

Understanding Color

Color, also referred to as hue, is based on the three primary colors. From these all other colors are derived.

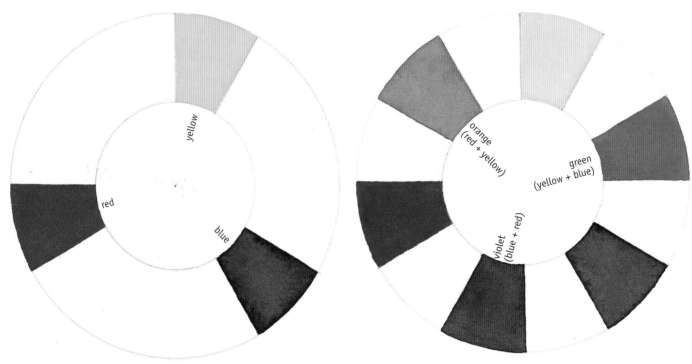

Primary Colors
Red, yellow and blue can't be made from other colors.

Secondary Colors
Orange, green and violet result from mixing two of the three primary colors.

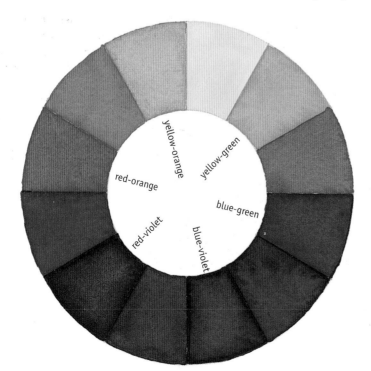

Tertiary Colors
These colors result from mixing a primary color with its adjacent secondary color.

Using Complementary and Analogous Colors

Complementary colors are any two colors that appear opposite each other on the color wheel. Analogous colors are a range of neighboring colors that make up a portion of the color wheel—red-orange, orange, yellow-orange and yellow, for example.

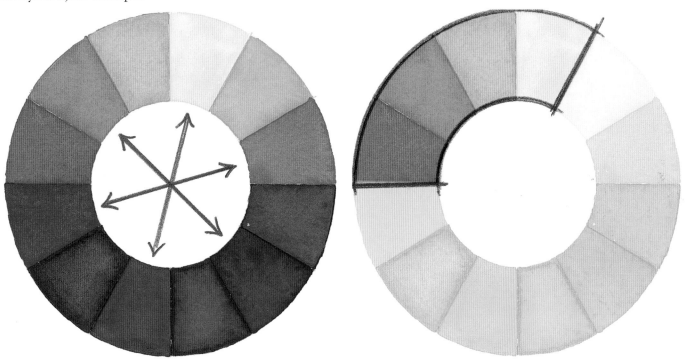

Complementary Colors
Colors that are directly opposite each other are considered a pair of complementary colors—red and green, for example.

Analogous Colors
A group of analogous colors always includes just one primary color.

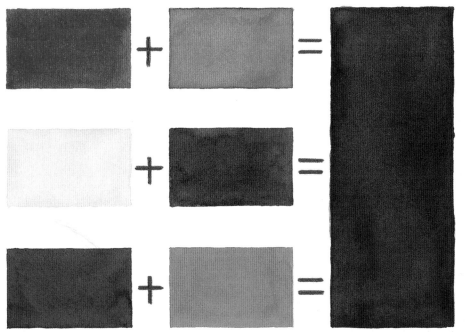

Mixing Complementary Colors
A pair of complementary colors is made up of one primary and one secondary color. If you mix a pair of complementary colors together, you've combined all three primary colors, which will result in a neutral gray or brown. If you mix the primary color red with its complement green (yellow plus blue), you'll get a brown mixture. The same result occurs if you mix yellow with its complement, violet (blue plus red), or if you mix blue and the color orange (yellow plus red).

Understanding Color Temperature

Warm colors are the reds, oranges and yellows and are also referred to as aggressive colors because they give the impression of coming forward. Cool colors, greens, blues and violets, are referred to as recessive colors because they give the impression of dropping back.

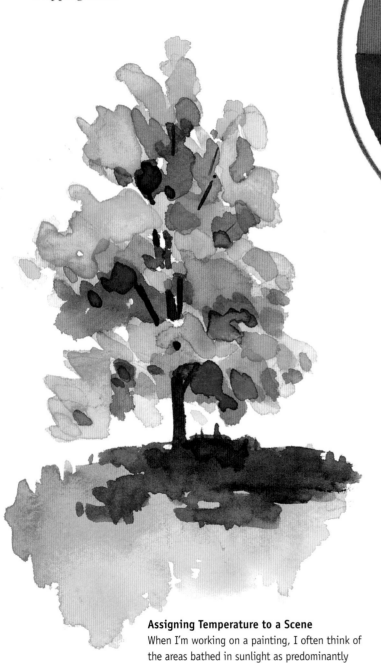

Assigning Temperature on the Color Wheel
Yellow-green and red-violet fall between warm and cool and can be used as warm or cool. You can use color temperature along with linear and atmospheric perspectives to emphasize depth.

Assigning Temperature to a Scene
When I'm working on a painting, I often think of the areas bathed in sunlight as predominantly warm colors and the areas in shadow as predominately cool colors.

Making a Color Wheel

You'll need one sheet of 140-lb. (300gsm) cold-press paper; tracing paper; a 2B tracing pencil; alizarin crimson, cadmium yellow and Prussian blue paints; a no. 10 round brush and water. Refer to the color wheels on page 30 for help.

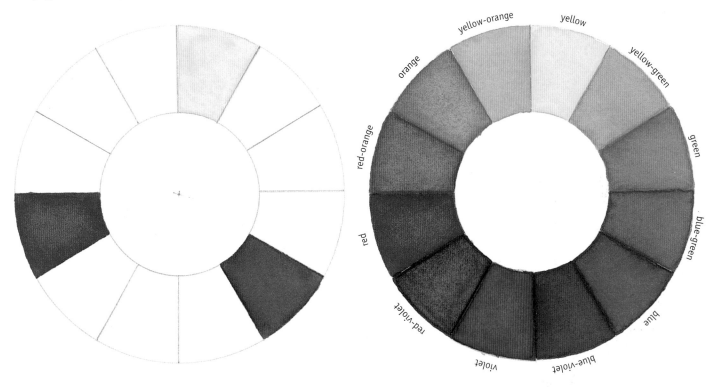

Creating a Color Wheel From the Primary Colors

Trace this wheel onto tracing paper and then onto 140-lb. (300gsm) cold-press paper. Your color wheel doesn't have to be this neat; you may prefer just to lay down swatches of color in a circular arrangement. Paint the primary colors in every fourth block as done above. Then mix each primary color with each of the other primary color to make the secondary colors. Paint these between the primary colors so every other block has color. Make sure you leave enough of each secondary color on your palette to mix the tertiary colors. Mix each of the primary colors with the adjacent secondary color to create the six tertiary colors: yellow and orange for yellow-orange, yellow and green for yellow-green and so on. Paint the tertiary colors in the remaining blocks.

Finished Color Wheel

Your color wheel should look something like this.

Planning Composition

Composition refers to the arrangement of elements in a picture. Whether simple or complex, composition always plays a part in a piece of artwork. Good composition rarely happens by chance. It involves planning before and during the painting process. Practice the following basic principles while planning and painting your artwork.

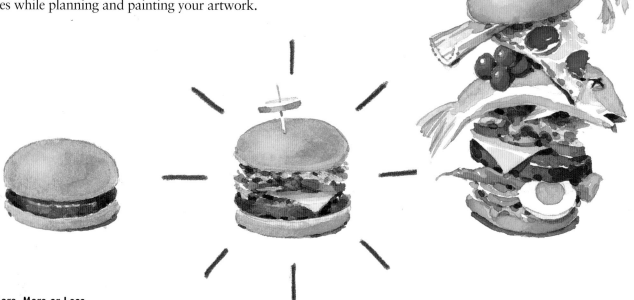

Less Is More, More or Less
Too much of a good thing can be overwhelming. Too little results in a bland painting. Think of a composition as a hamburger. There's more to a good burger than meat and a bun, but if you add everything you have in the refrigerator, it may be hard to swallow! Instead, enhance the flavor with just a few complementary ingredients.

Odds Add Interest
Odd numbers tend to look more interesting. An even number of elements can make the painting look too structured, so it may seem balanced but also looks repetitive. An odd number, on the other hand, is more interesting to the viewer. This concept also applies to the number of elements that overlap the edges of the painting.

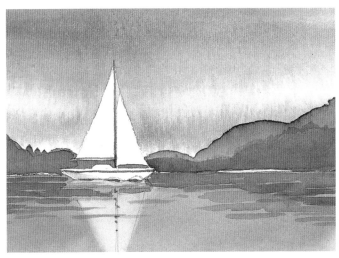

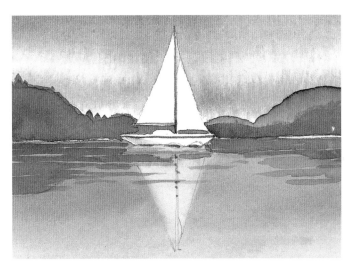

Asymmetrical vs. Symmetrical

A symmetrical composition like the one at the right may look orderly and structured, static and bland. Let's face it: Structure can be boring sometimes, and viewers of your artwork may start to yawn. The asymmetrical composition above gives an interesting, random feel to the painting.

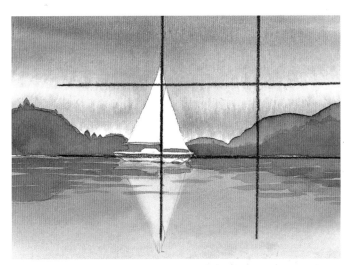

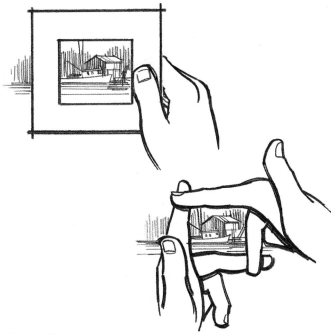

An Odd Way of Looking at Things

The concept of odd numbers works in more ways than one. Don't just use odd numbers of elements; also divide the painting into an odd number of parts. Imagine a grid that splits your painting into thirds horizontally and vertically. Place objects close to the intersection points of these lines to make an appealing composition.

Using a Viewfinder

Some subject matter can be daunting. Landscapes in particular can be overwhelming to a painter trying to capture the great outdoors within the dimensions of a piece of paper. Use a viewfinder to focus in on a manageable composition. You can make your own viewfinder by using a craft knife and straight edge to cut a hole out of a piece of cardboard. You can also form your fingers into the shape of a rectangle.

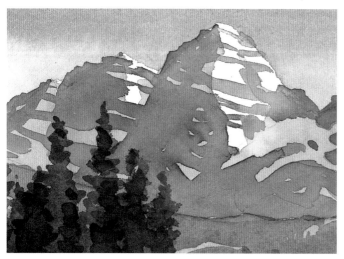

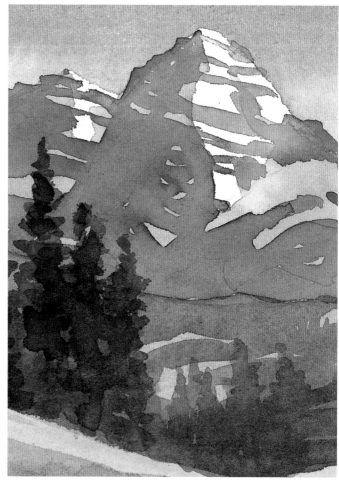

Horizontal or Vertical

Different formats affect viewers differently. Horizontal formats lend themselves to calm, peaceful scenes. In the example above, the width of the horizontal format emphasizes the sturdiness and stability of the mountain. Vertical formats lend themselves to dramatic, intense scenes. In the example at right, the vertical format emphasizes the height and power of the mountain and gives the viewer a feeling of awe.

Don't Fence Me Out!

Walls and fences in the lower portion of a painting give an unfriendly feeling that shuts out the viewer. If you want to place a wall or fence in the foreground, add an open gate to make the scene more inviting.

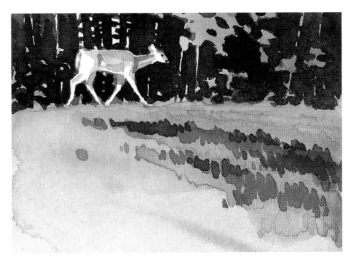

Angles Add Action

Angled lines and elements give the impression of movement, which adds action and liveliness to a picture.

Plan Leading Lines

You can form lines in a composition that direct the viewer's eye to points of interest or guide the eye through the painting. In this case, the shadowy area in the foreground leads the viewer's eye to the point of interest, the deer.

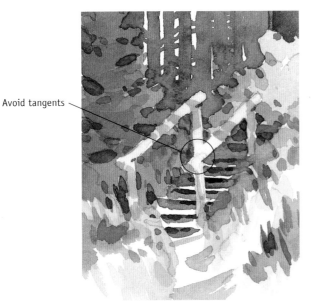

Avoid tangents

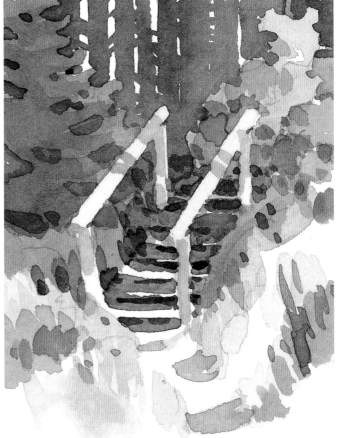

Avoid Tangents

In the painting above, the handrail and two of the posts all meet at one point, called a tangent. The composition becomes confusing when the viewer can't see where one object stops and another starts. The painting at right is much easier to comprehend. It uses the same composition viewed from a different perspective.

Following the Painting Process

Watercolors are said to be unforgiving because once you've applied them to paper, they're difficult or even impossible to change. Artists can easily become overly cautious and timid with their paints, which results in a pale, stiff and unexciting painting. Instead, embrace the unpredictability of watercolors and incorporate it into your painting.

Planning

There's more to the painting process than simply applying paint to paper. To maintain control over your painting, plan ahead and to give yourself confidence. If you plan your painting well, you won't need to worry about the fact that there are no "do-overs" in watercolor. Decide on the structure, values and colors you'll use before you start painting.

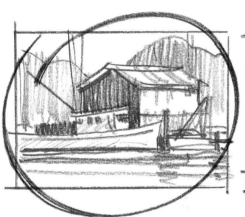
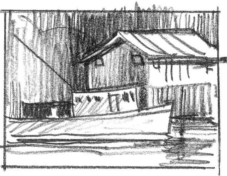
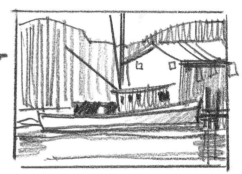

Thumbnail Value Sketches

Draw a few thumbnail sketches of the scene you're going to paint on sketch paper with a 2B pencil. These small, quick sketches show different approaches to value, composition and cropping. I prefer my first sketch because the composition and values lead the eye to the focal point while producing a balanced and interesting scene.

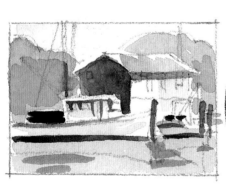
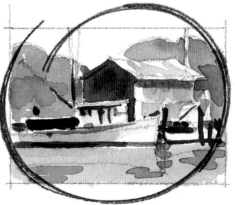
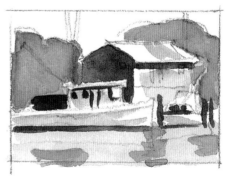

Color Sketches

Now work up some different color schemes using the thumbnail value sketch you chose. On scrap watercolor paper, draw the structural lines without the values. Then try different color schemes, paying attention to the values of the colors you're auditioning. I prefer the direction and balance created by the use of warm and cool colors in my second color sketch. I'll use this as a reference for my final painting.

Drawing

Once you're satisfied with your composition, values and colors, draw the structural drawing that will serve as the basis of your final painting. If you're confident in your drawing skills, go ahead and draw directly onto your watercolor painting. Be careful, though. If you redraw or erase too much before painting, you'll damage the paper so paint will streak and spot. If you prefer, take a few extra minutes to draw the structural drawing on a regular sheet of paper and then trace or transfer it to watercolor paper once you're satisfied with it.

Tracing

To trace your structural drawing, you'll need a form of backlighting. Secure a piece of watercolor paper over the structural drawing with masking tape. Then attach both to your light source: a light box or a window. Trace the image with a 2B pencil. If you need to erase any lines, use a kneaded eraser, which is less abrasive than other erasers.

Heavy watercolor paper, such as 300-lb. (640gsm) paper, is too thick to use for tracing. Watercolor paper in block form is also impractical for tracing. If you're using thick paper or a watercolor block, you can transfer the structural drawing onto your watercolor paper (see page 40) rather than trace it.

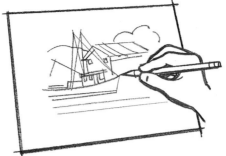

Structural Lines
With a 2B pencil, lightly draw the structure of the subject onto watercolor paper. Don't worry about indicating values here; just draw the structural lines.

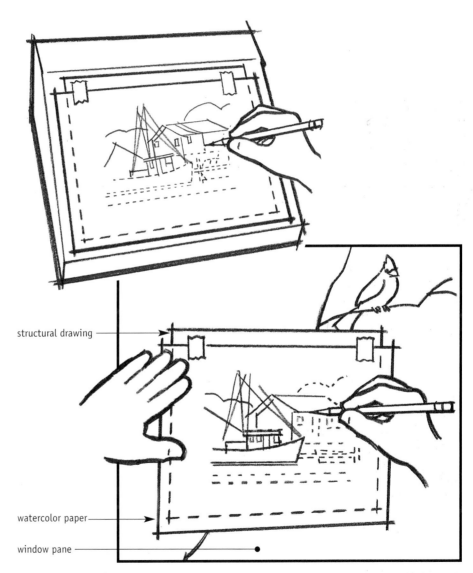

structural drawing

watercolor paper

window pane

Light Sources for Tracing
You can use a light box or a window as backlighting when tracing an image onto watercolor paper. The light outside must be brighter than the light inside so you can see through the watercolor paper. Try to find a window where you can sit to trace.

Transferring

To transfer an image, you'll need a graphite transfer sheet. As you press down on the transfer sheet, graphite transfers onto the watercolor paper. I make my own transfer sheets because commercial versions leave waxy lines that repel paint from the watercolor paper and are hard to erase.

Make Graphite Paper
Cover one side of an 11" x 14" (28cm x 36cm) piece of tracing paper with graphite using a 2B pencil. Zigzag down the paper in columns until the paper is completely and evenly covered. Rotate your paper forty-five degrees and repeat this process so the new lines crisscross the original ones.

Bind Graphite to Paper
Dampen a cotton ball with rubbing alcohol and wipe it across the graphite. The rubbing alcohol evens out the graphite and binds it to the surface of the paper so it's no longer powdery. Keep the surface as dry as possible while smearing the graphite, to avoid wrinkling the paper. Some wrinkling is bound to happen, but too much alcohol—and it doesn't take much—will keep the paper from lying flat. Let the sheet dry.

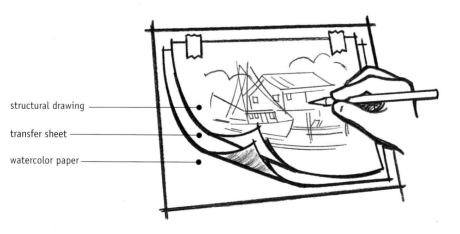

structural drawing

transfer sheet

watercolor paper

Transfer Image
With the graphite side facing down, place the transfer sheet on top of the watercolor paper and then place the structural drawing face up on top of the transfer sheet. Tape the sheets together with masking tape so they won't slip. Then go over the lines of the structural drawing with a hard lead pencil, such as a 2H pencil, and press hard enough to transfer the image, but not so hard as to leave deep grooves in the watercolor paper. Check to make sure the image is transferring to your watercolor paper before you get too far into the process.

Painting

Now you've got a structural drawing on your watercolor paper whether from a direct drawing, tracing or transferring. If the paper you're working on is in block form, you're finally ready to start painting. If you're working on a loose sheet of watercolor paper, mount it to a board or stretch it with sealing tape or clips as described on page 13, then start painting.

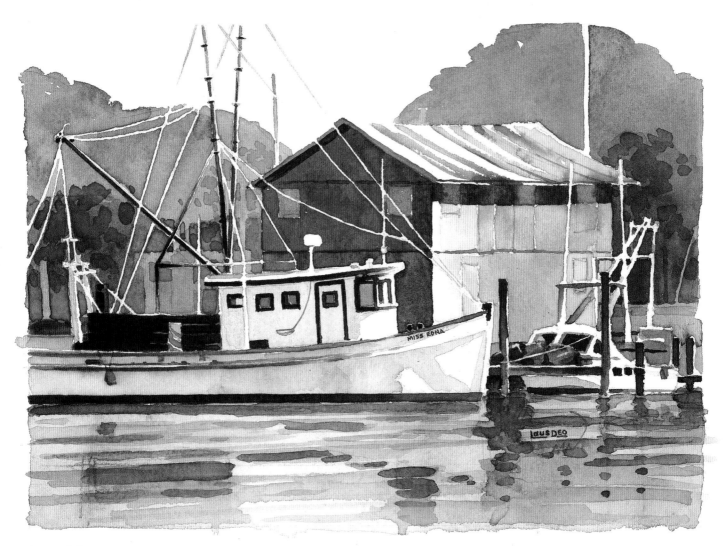

Time to Paint
Once the paint is dry, erase your pencil lines with a kneaded eraser, sign and date your painting and you're done!

Miss Edna, Mooring
5½" x 8" (14cm x 20cm)
140-lb. (300gsm) cold-press watercolor paper

Discussing Basic Principles

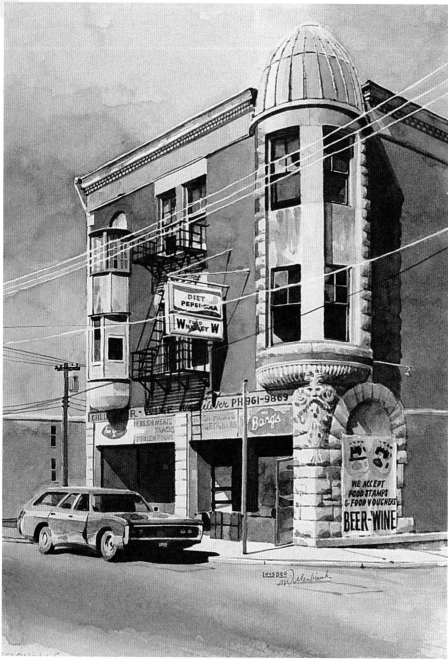

WW Market
9½" x 7½" (24cm x 19cm)
140-lb. (300gsm) hot-press watercolor paper

Linear Perspective

Linear perspective brings realism and believability to a painting, especially architectural subjects. As I drew this building, I established the two vanishing points, using a straight edge for accuracy. I established atmospheric perspective, too, using brown madder, a warm color in the foreground and the cooler Prussian blue in the sky and background. I mixed the two colors for the cool, dark shadows. Notice that the lightest part of the building is closest to the viewer. I painted this scene from a reference photo taken on a sunny Sunday morning when the contrast between light and dark areas was strong. The building itself isn't the most likely subject, other factors like the perspective and composition of the scene made it an interesting and fun picture to paint.

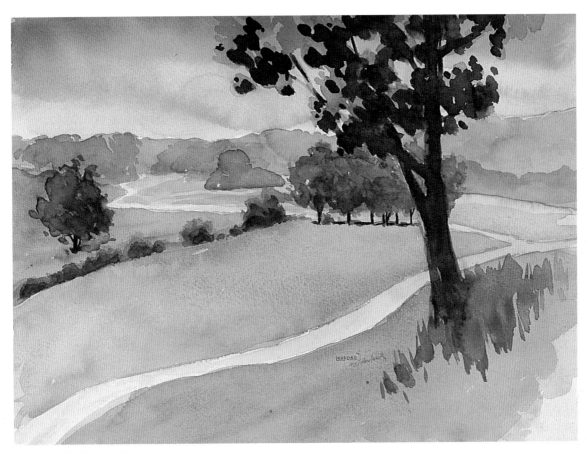

Atmospheric Perspective

Using atmospheric perspective in addition to linear perspective adds a feeling of depth to scenes like this painting. I took one of my classes to this location for a plein air painting demonstration. Painting plein air forces you to work quickly while really observing the subject. The class studied the way the sky and shadows looked when we started painting, and made a mental note to follow that guide. The light source, the sun, in plein air painting is constantly changing, so you have to keep it consistent in your painting even if it is changing in reality. Notice that the colors in the foreground in this painting are richer and more intense with more contrast, while the background colors are cooler and more muted and neutral. When painting plein air, you can work on a painting or just a sketch that you'll use to paint a final painting later. Either way, the important thing is to relax and enjoy the experience. Whether you end up with a masterpiece or not, you'll improve your observation and technical skills, which are invaluable to future paintings.

Meadow Trail
12" x 16" (30cm x 41cm)
140-lb. (300gsm) cold-press watercolor paper

Practice the Techniques

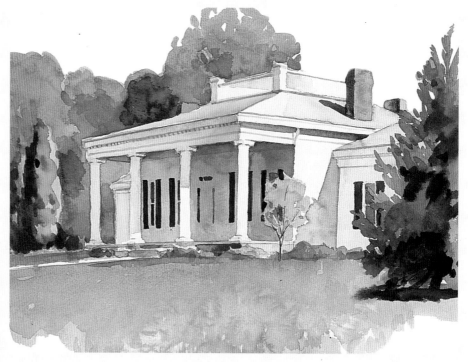

Painting with watercolors is fun, and it's even more exciting when you learn the techniques unique to this particular medium. In this chapter you'll learn some easy techniques that will bring more creativity, interest and enjoyment to your watercolor painting experiences.

Mixing Paint and Handling Brushes

Unlike other mediums, watercolor paints are supposed to be used transparently to utilize their luminescent qualities, so you have to mix the paint with water before applying it to paper. Whenever I talk about a color in this book, I'm referring to a mixture of water and paint. The ratio of paint to water that you should use depends on how light or dark you want a color to be. Only hands-on experience can teach you how much water and paint to use to get the results you want.

The idea behind mixing colors is to start with a base color, or the lightest color, and then add small amounts of the darker color or colors until you get the color you want. If two colors are equally dark, think back to the color wheel. Green and blue can be equally dark, but green is made up of yellow and blue. Yellow is lighter than blue, and green has yellow in it, so it should be the base color. Start with green and add bits of blue until you get the color you want. Then add water until you get a good, working consistency.

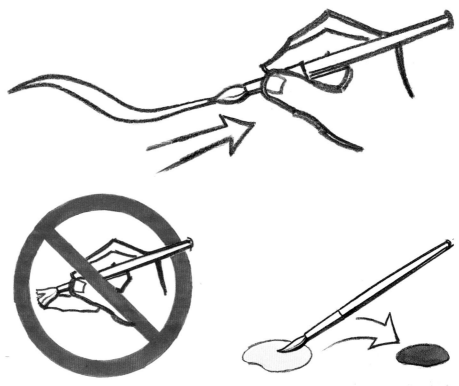

Using Brushes Correctly
Watercolor brushes can be pricey. Handle them carefully to get the most mileage out of them. A good round brush has bristles that come to a fine point. To maintain the point, gently pull or draw the brush away from the hairs toward the handle as you paint. Pushing or scrubbing with a brush can ruin the fine point that your brush once made.

Mixing Colors
Start with the lighter colors. Darker colors are more dominant than lighter colors and can overpower them.

Don't Skimp
Don't worry about using too much paint or water. Beginners often mix too little and then try to stretch what little they have. This means your paint application will be weak and pale or you'll spend lots of time trying to make another mixture of the exact same color and value to finish your painting. The mixture at left is much more realistic than the mixture at right. "Fresh squeezed" paints from the tube are more soluble than paints that have dried out on your palette. Use fresh paints to avoid pale colors.

Painting Wet-on-Wet

To work wet-on-wet, apply a brush loaded with paint to wet paper. This technique offers less control than wet-on-dry or dry-brush techniques, which you'll learn about on page 48, but it also offers plenty of unique and unexpected results. Applying paint wet-on-wet allows the painter to use loose strokes and bold colors.

Time is of the essence when you're working wet-on-wet because you need to finish painting the area before the paper dries. Choose your colors and mix lots of paint and water on the palette before you wet the paper. Use a big, wide brush to cover the area with water just before you begin to paint so the whole area is covered with a smooth, even sheen. If the paper is too wet or too dry, the color won't bleed out smoothly.

The paint should transfer easily from the brush to the paper and spread to areas where the paper is wet.

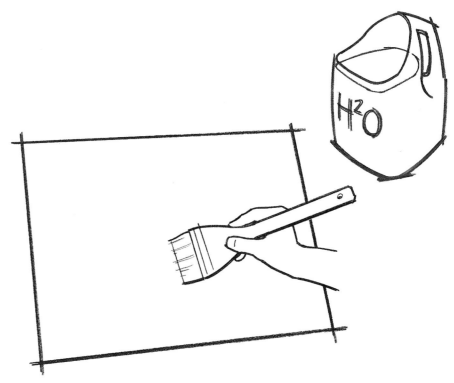

Apply Water
Wet the surface of the paper with a wide, flat brush filled with water. Use long, straight, back-and-forth strokes. The entire area you want to paint should have an even sheen just before you start painting.

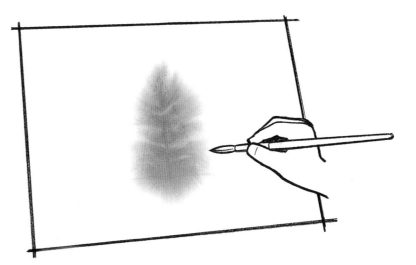

Apply Color
Load a brush with paint and gently touch or sweep the brush along the paper surface so the color transfers from the brush to the damp paper. Remember that these are watercolors—trying to brush the paint into submission once it's been applied can cause smearing. After the color leaves your brush, let the spontaneity of watercolors take over.

What Paper to Use

The smooth surface of hot-press paper doesn't allow paint to spread out as much as cold-press or rough paper does, though I do like the interesting watermarks and hard edges. If you want to create soft edges with the wet-on-wet technique, use cold-press or rough paper.

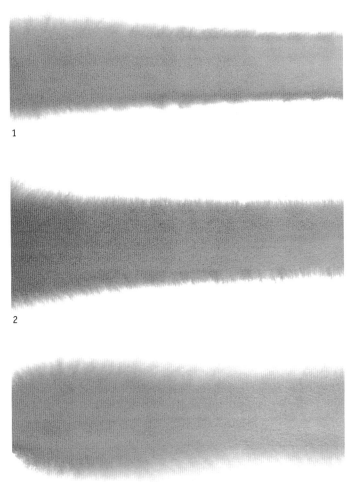

1

2

3

4

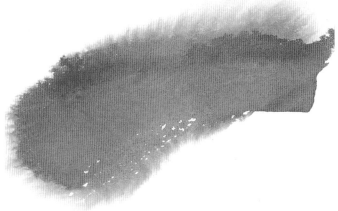

5

Wet-on-Wet on Different Papers
Examples of this painting technique on different papers appear above: hot-press (1), cold-press (2) and rough (3).

How Much Water Do I Use?
The trick when painting wet-on-wet is to apply just the right amount of water to the paper before painting. If the surface is too wet (4), it won't want to accept the color, and you'll get pale, uneven results. Before adding color, gently smooth any puddles of water so you have a thin, even sheen of water over the paper's surface. If the surface is too dry (5), the color may bleed out in an inconsistent manner. Don't get frustrated. It may take some practice to learn how much water to use.

Painting Wet-on-Dry and Drybrushing

Wet-on-wet, wet-on-dry and dry-brush techniques are synonymous with watercolor. Often, all three are used in one painting.

Wet-on-Dry

To paint wet-on-dry, apply a wet brush loaded with paint to dry paper. Because there is no water on the paper to help the paint disperse, wet on dry produces defined strokes with hard edges. Different papers react similarly to the wet-on-dry technique. However, the smooth surface of hot-press paper allows cleaner edges.

Dry Brush

The dry-brush technique uses dry paper and a dry brush loaded with a mixture that has very little water. Hot-press paper lets very little texture show through after you've painted over it. Rough paper shows plenty of texture. If you want to use wet-on-dry or dry brush techniques, make sure the area is completely dry before painting.

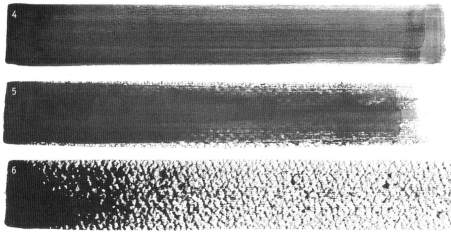

Wet-on-Dry on Different Papers
Examples of this technique used on different papers appear above: hot-press (1), cold-press (2) and rough (3).

Dry Brush on Different Papers
Examples of this technique used on different papers appear above: hot-press (4), cold-press (5) and rough (6).

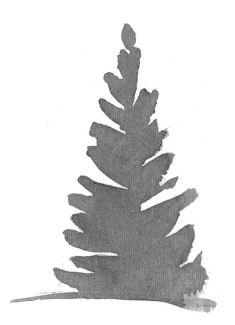
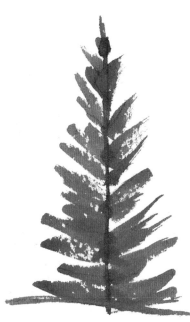

Use Very Little Water for Drybrushing
Mix the paint with just enough water to allow the mixture to transfer from the brush to the dry paper. The example far left shows too much water used.

Applying a Flat Wash

A flat wash covers a large area with even color. You need to work quickly to cover the surface evenly, finishing the wash before any part dries.

Make a generous mixture on your palette so you'll have enough paint to work quickly. For big washes, use a second palette or the palette cover so you'll have enough room to create a big mixture.

Paper quality makes a big difference when painting washes. In general, professional-grade paper stays wet longer, providing more time to work on the wash. Good paper also accepts multiple washes better than student-grade paper. For paintings larger than 11" x 17" (28cm x 43cm), use nothing thinner than 300-lb. (640gsm) paper to prevent wrinkling.

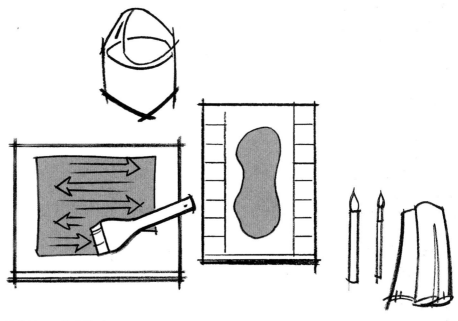

Painting a Flat Wash

Lay out paper, a palette, a water container, a rag and three brushes—one for mixing, one for painting and one for pulling up puddles of extra paint—within easy reach. Use a separate brush to mix the paint so you won't have undiluted clumps of pigment on the brush you're using for painting.

Load a wide, flat brush with the paint mixture. I use a 3-inch (76mm) hake brush for 8" x 10" (20cm x 25cm) areas—the larger the area, the wider the brush. Cover as much space as possible at once. Stand when you paint washes so you have plenty of freedom of movement. Stroke across the top of the dry paper. Load the brush again and make another stroke, this time in the opposite direction and overlapping the bottom of the previous stroke by about a third. Continue this process—loading the brush and stroking back and forth down the paper until the area is covered.

Flat, Even Color
A flat wash covers the paper evenly and doesn't vary in value or color.

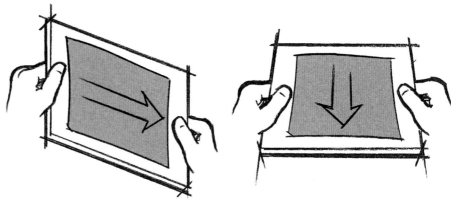

Tilting Your Paper

As long as the painted area is still very wet and hasn't started to dry yet, you can tilt your paper to even out the paint. Tilt it back and forth in whatever direction necessary to smooth out any lines. Then use a dry brush to lift any puddles of water that may have formed of the edges of the wash. This prevents the extra water from running back in. If the finished results aren't as dark as you wanted, wait for the area to dry completely and repeat the wash. A word of caution: Some cheaper papers don't absorb repeated washes well, and the paint will smear instead.

Applying a Gradated Wash

A gradated wash changes value. You must work quickly to complete the wash before any part of it dries.

Work on a wash from light to dark. If you try to apply a gradated wash from dark to light, you'll waste precious time cleaning the dark color out of your brush before moving on to the lighter value. If you want a wash to go from dark to light, turn your paper upside down and paint from light to dark.

To save much needed time, make a big gradated mixture on your palette before you start painting. First, make a big puddle of clear water at the top of the palette. Then, make a big puddle of a dark mixture at the bottom of the palette. Join the two puddles in the middle to make one mixture that gradates from almost clear water to a dark mixture.

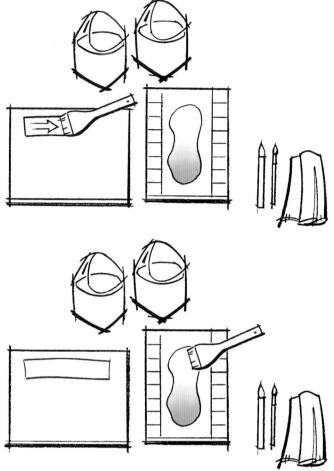

Gradual Transition
Apply the paint and water mixture so the wash begins as mostly water and gradates to more and more color.

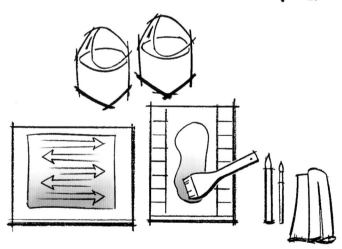

Add More Color As You Go
Make another stroke in the opposite direction, overlapping the bottom of the previous stroke by about a third. Continue this process—loading the brush and stroking back and forth from the top to the bottom of the paper. As long as the painted area is still very wet and hasn't begun to dry, smooth the wash by tilting your paper. Lift up any puddles at the edges with a dry brush to prevent backruns. If you want the wash to be darker, repeat it after the first wash has dried.

Start With Water
Lay out your supplies the same way you did for a flat wash, using two water containers instead of one. Use the water on the left for making the mixture and the water on the right for cleaning your brushes. Load a wide, flat brush with clear water. While standing, stroke the brush across the dry paper.

Add Some Color
Load the brush again, this time from the top portion of the puddle on your palette.

Applying a Variegated Wash

A variegated wash changes from one color to another, with the two colors blending in the middle.

Just as you mixed a gradated wash on your palette, mix a variegated wash before painting. Make a big puddle of the first paint mixture at the top of the palette. In the example on this page, I used Prussian blue. Wash out your brush and make another puddle of the second paint mixture at the bottom of the palette. I used alizarin crimson in this example. Join the puddles so the two colors bleed together to make one big puddle of paint that gradates from blue to purple to crimson.

Multiple Transitions
A variegated wash changes from one color to another, blending the two in the middle.

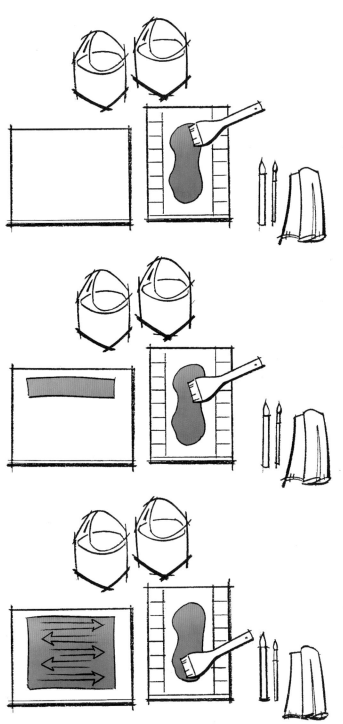

Start With One Color
Lay out your supplies as you did for the gradated wash, including two water containers. Load a clean, wide flat brush from the top of the paint mixture.

Continue With More Color
While standing, stroke the brush across the dry paper. Then load the brush from a slightly lower part of the puddle.

Smooth Out the Wash
Make another stroke in the opposite direction, overlapping the bottom of the previous stroke by about a third. Continue this process—loading the brush from the palette, from the top down, and stroking back and forth to the bottom of the paper. As long as the area hasn't begun to dry, smooth out the wash by tilting your paper. Lift any puddles at the edges to prevent back runs. If the finished results aren't as dark as you'd like, repeat the wash after the first one has dried completely.

Something's Wrong With My Wash

So you've been practicing, and your wash just didn't turn out like you thought it would. Here are some pitfalls artists often fall into. Once you've identified the problem, keep practicing until you get it right.

Unwanted Streaks and Lines Appeared

Unwanted streaks and lines appear if you try to cover a large area with a brush that is too small. Work quickly with as large a brush as possible so the wash won't start to dry before you're finished.

Paint Dried Unevenly

Starting in the middle of the area you want to cover makes your job harder than it has to be. The paint on the outer edge starts to dry before the paint in the middle. If you overlap the edge with a stroke of wet paint, the edge of the first stroke will show. Each area should dry at the same time. Start at a corner and work outward so you won't have to overlap old strokes.

Watermarks From Backruns Occurred

Puddles of excess fluid left at the edges of a wash can run back into the area starting to dry and cause watermarks. Touch the tip of a dry brush—sometimes called a thirsty brush—to the puddle while the paper is still wet to lift the extra fluid from the paper. Dry the brush with a rag and repeat as many times as necessary. Be careful not to smear any paint that has begun to settle.

Paint Smeared

Watercolors are not like oils or acrylics. Brushing the paint once it begins to settle can smear the paint. Once watercolor paint starts to dry, it's out of your hands. Don't overwork it.

Second Wash Repelled Color

Applying another wash before the previous one has dried may smear or repel the color from the first wash. Make sure each wash is completely dry before starting another one.

UFO's Have Invaded

"Unwanted Foreign Objects," such as dust, lint, cat hair and oil from fingerprints, cause streaks and spots if they end up in your wash before it dries. Make sure anything that comes in contact with the paper, such as paint, a rag or brushes, is clean before you use it, and don't handle the surface of the paper any more than you have to.

Positive and Negative Painting

Negative painting is an easy technique to learn when painting with watercolors. You just need to plan ahead. You might paint the negative space of an object around a white area or over a previous wash of color. It's easy to plan what areas to leave untouched if indicating a white object, such as white water in rapids. Take the challenge of painting an object that normally is brown, such as a fence, by leaving the fence white and painting the shapes around it.

You can make a dull, drab fence into an interesting part of your composition. Use negative painting as a way to present an ordinary image in a unique way. I like to imply the shapes of daisies on a dark background using negative painting.

negative painting

positive painting

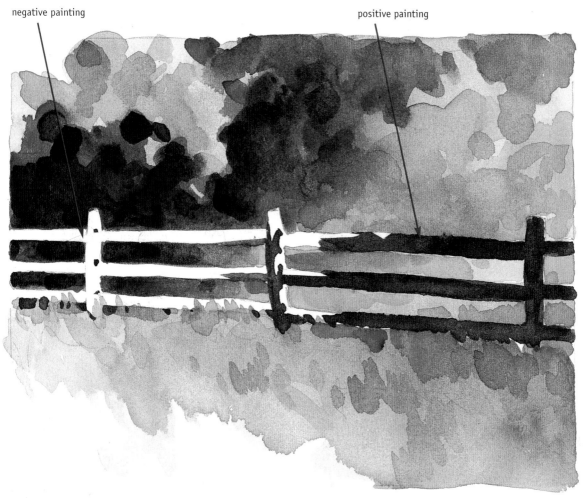

Imply Shapes
Negative painting implies an image by painting the shapes around it. Positive painting, in contrast, means simply painting the object. To paint a fence using negative painting, for instance, you'd leave the white of the paper for the fence and define the fence's shape by painting the colors of the foliage behind it. To paint the fence positively, the brushstrokes themselves should indicate the fence posts and rails. Carefully plan your composition before painting. Draw all of the shapes in lightly, then paint around the object, only implying its shape.

Painting Straight Lines

You can use a straight edge, such as a ruler, to make long, straight lines. Following the edge with a round brush, as you would with a pencil, can cause the paint to spill under the ruler with unpredictable results. Instead, follow the technique below.

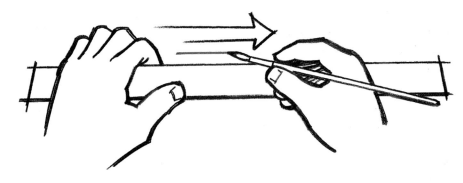

Steadying Your Hand

Prop up the ruler with the hand you don't paint with, resting your fingers between the surface and the back of the ruler. Place your thumb along the front of the ruler to stabilize it. The top edge of the ruler should be elevated while the bottom edge rests on the paper.

Next, load a no. 2 or no. 6 round brush with paint. Place the ferrule, or metal part, of the brush so it rests on the ruler's edge. Paint the line by dropping the tip of the brush to the surface of the paper. If you're right-handed, start at the left and pull the line to the right. If you're left-handed, start at the right and pull the line to the left. Let the ferrule ride along the edge of the ruler.

Using Straight Lines in a Painting

I painted most of this scene loosely, but the contrast of the straight lines on the blades really brings the focus to the windmill and makes a bold statement. The straight lines make the mill look much more realistic than freehand lines would indicate.

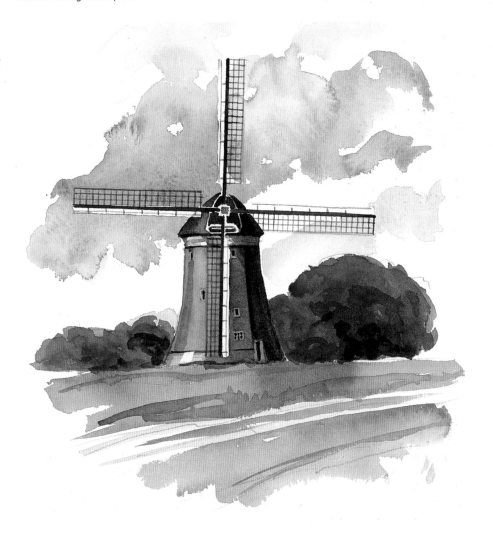

Creating Texture

You can create texture by moving or disbursing paint while it's still wet. The results vary depending on the type of paper you use and how damp you make the paper. Experiment on scrap watercolor paper before trying any of these techniques on a painting. Keep your practice scraps and trim them to be used as bookmarks or note-cards. Applying textures can be great fun, but texture shouldn't be the main attraction of a painting. Instead it should enhance the overall theme.

Adding More Water

Apply a wash of color and let it stand until almost dry. Then touch the tip of a round brush loaded with water onto the wet surface. This water will push away the previously applied wet paint. This technique works well for elements like the leaves above. To emphasize contrast in these areas, you can use a tissue to carefully blot the center of a freshly painted area.

Adding More Paint

Rather than applying more water, you can apply a paint mixture. The mixture will push away the previously applied wet paint. This is similar to painting wet-on-wet, except now you'll wait until the paint from the previous wash is almost dry before applying a second color. The colors won't blend smoothly as in a wet-on-wet wash, but instead they'll push against each other to create unique textural effects. Experiment on scraps of watercolor paper to be certain of the results before using this technique in a painting.

Adding Salt

Hold grains of salt between your thumb and forefinger and drop them onto the wet surface of a freshly applied wash. Be patient. The effect doesn't always appear immediately. The salt continues to work its magic until the wash dries completely. Don't use a hair dryer to speed up drying time, though. When the wash is dry, gently wipe away remaining salt crystals. Bigger salt grains, such as coarse kosher salt and rock salt, leave bigger splotches than regular table salt.

Use Different Amounts of Water
The results can vary depending on the dampness of the paper. In the example top, I added table salt once the wash looked like a thin sheen. The wash above practically had puddles when I added the table salt. Experiment adding salt at varying levels of dampness. The wetter the wash, the more the salt spreads and dissolves, which results in a subtle texture.

Lifting Paint

After you've applied a wash, you can lift some of the paint from the surface before it has dried. Professional-grade papers usually respond better to this technique.

Lifting With a Tissue
While the wash is still damp, bunch up a facial tissue, press it firmly against the paper and quickly pull it away to lift some of the paint. This technique works well for clouds, for example.

Lifting With a Paintbrush
Drag an old, dry brush over a wash of color that is nearly dry. The pressure you need to use could damage a good brush. This technique works well to paint weathered wood.

Spattering

Random dots can add a rustic feel to a watering can or imply the texture of sand on a beach. Practice on a scrap piece of paper to get used to the results. Use scrap paper to cover any area where you don't want the dots to land.

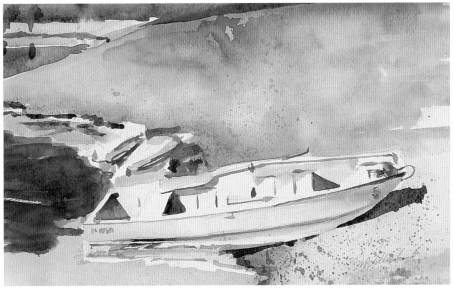

Indicating Sand
Spattering with two paintbrushes produces fewer dots, but they're bigger. Spattering with a comb and a toothbrush produces lots of small dots. I painted the dots above using two brushes.

Return From Fishing
7½" x 13"
(19cm x 33cm)
140-lb. (300gsm) cold-press watercolor paper

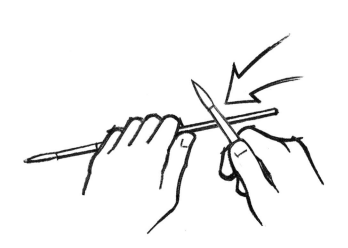

Two Paintbrushes
Gently tap one paintbrush loaded with paint against the handle of another paintbrush.

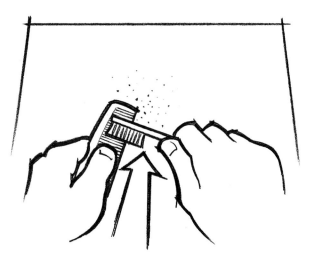

Toothbrush and Comb
Instead of brushes, you can also use a toothbrush and comb. Load the toothbrush with paint and drag it over the teeth of a comb with the tip pointed toward the watercolor paper.

Applying a Wrap

Placing some nonabsorbent material, such as plastic wrap or aluminum foil, over wet paint gives an impression of marble.

Plastic Wrap

Lay crumpled plastic wrap over a thick puddle of paint sitting on the paper. Let it dry for several hours before removing the plastic wrap. For softer, less defined edges, pull the wrap up before the paint dries completely.

Aluminum Foil

Aluminum foil also works, but you won't be able to see the results until you lift it off. Foil doesn't cling to a wet surface like plastic wrap does, so I place a heavy book on top of it to make a good impression. You can either crease the foil to make straight lines or crumple it for a marble effect.

Stenciling and Imprinting

Use your imagination to think of household items you can use to create texture. To stencil, place an item, such as an onion or potato bag, over the surface and paint over it. To imprint a texture, apply paint to an item, such as a sponge, and then press the item onto dry paper.

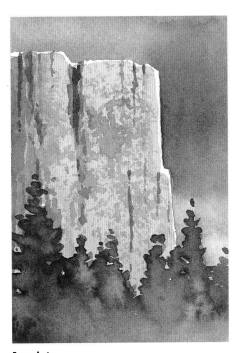

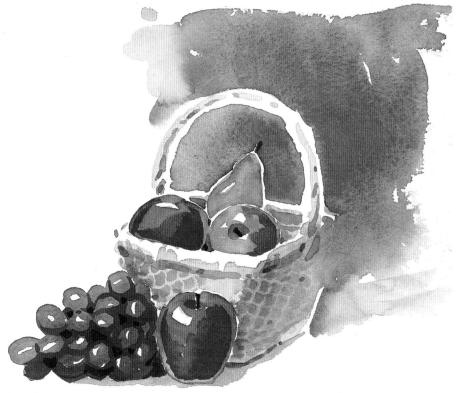

Imprint

Leave an imprint on the paper by pressing an item, such as a sponge, that is loaded with paint against a dry surface. You can apply an imprint on blank paper or over a wash of color.

Stencil

Use large mesh material, such as an onion bag, as a stencil to make a patterned effect. Load a 1-inch (25mm) flat brush that has firm bristles with a paint mixture. While holding the flat onion bag firmly in place, drag the brush over the bag. You can use stenciling to add a patterned texture to something like this basket.

Matting and Framing

A watercolor painting isn't complete without a mat and frame. Correctly matching a mat and frame to the composition of your painting will dramatically enhance it.

Use the table on page 63 as a guide for the sizes of mats and frames to use for your paintings. This information is based on standard paper, mat and frame sizes. The image size is the amount of the paper that will show after you've matted the painting. It's OK to paint bigger than this and let the mat crop the scene for you.

If you're painting on 9" x 12" (23cm x 30cm) paper, for instance, an 11" x 14" (28cm x 36cm) mat will work well and allow an 8" x 10" (20cm x 25cm) area to show through. Or if you want a framed picture that is 12" x 16" (30cm x 41cm), go backwards through the chart to see that you should paint on 10" x 14" (25cm x 36cm) or 12" x 16" (30cm x 41cm) paper, and a 9" x 12" (23cm x 30cm) part of the image will show. You also can have mats custom cut to fill a frame or fit the paper you're working on.

Like paper, mat board that isn't acid free will yellow with age. Make sure you look for the acid-free label. If a picture is worth framing, it's worth the cost of acid-free mat board.

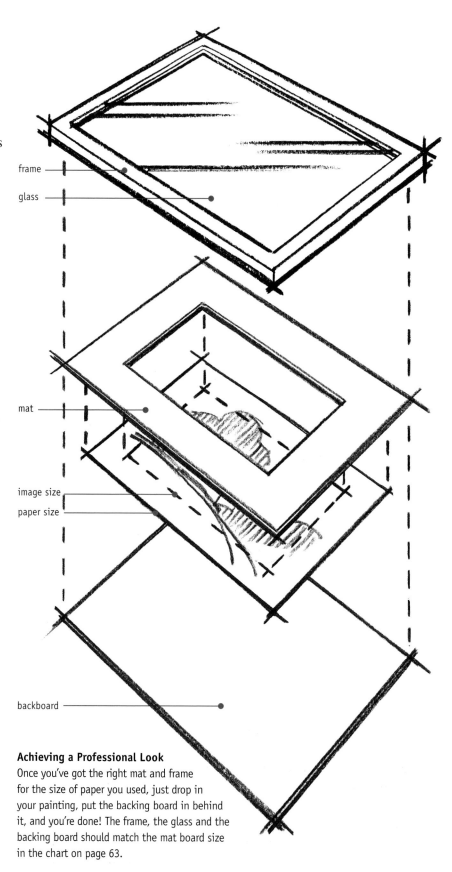

Achieving a Professional Look
Once you've got the right mat and frame for the size of paper you used, just drop in your painting, put the backing board in behind it, and you're done! The frame, the glass and the backing board should match the mat board size in the chart on page 63.

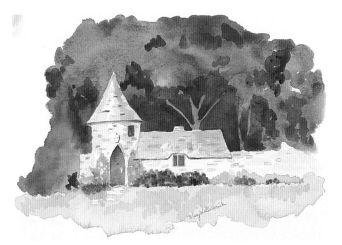

A Beginner's Efforts

I am the painter of this pair, and Mary considers herself an absolute beginner when it comes to watercolor, so we thought it would be helpful for you to see the result of Mary's efforts from the demonstration on page 72. She's proud enough of what she was able to do with the help of my demonstration to show the painting to some of her friends.

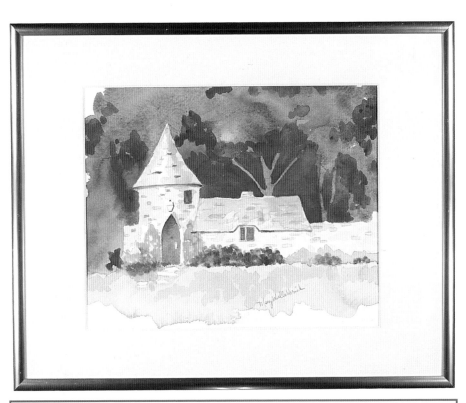

A Beginner's Professional Results

Look at the difference a mat and frame makes in creating a professional-looking product. Mary painted the 8" x 10" (20cm x 25cm) image on 10" x 14" (25cm x 36cm) paper and framed and matted it with an 11" x 14" (28cm x 36cm) mat and frame.

Camargo Gatehouse
Mary Willenbrink
8" x 10" (20cm x 25cm)
140-lb. (300gsm) cold-press watercolor paper

What Size Mat and Frame Do I Need?

Paper Size	Image Size	Mat and Frame Size
4" x 6" (10cm x 15cm)	3½" x 5" (9cm x 13cm)	5" x 7" (13cm x 18cm)
7" x 10" (18cm x 25cm)	5" x 7" (13cm x 18cm)	8" x 10" (20cm x 25cm)
9" x 12" (23cm x 30cm)	8" x 10" (20cm x 25cm)	11" x 14" (28cm x 36cm)
10" x 14" (25cm x 36cm)	8" x 10" (20cm x 25cm)	11" x 14" (28cm x 36cm)
10" x 14" (25cm x 36cm)	9" x 12" (23cm x 30cm)	12" x 16" (30cm x 41cm)
12" x 16" (30cm x 41cm)	9" x 12" (23cm x 30cm)	12" x 16" (30cm x 41cm)
14" x 20" (36cm x 51cm)	11" x 14" (28cm x 36cm)	16" x 20" (41cm x 51cm)

Discussing Techniques

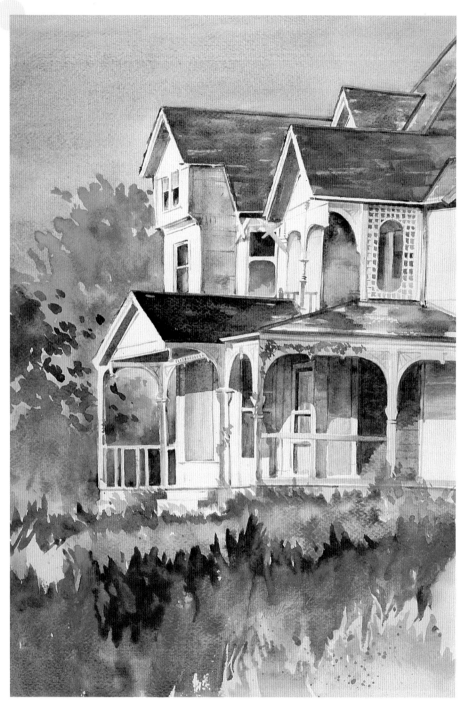

Victorian Repose
18" x 14" (46cm x 36cm)
140-lb. (300gsm) cold-press watercolor paper

Paint Techniques

I started this painting with the background, using a wet-on-wet technique. Then I concentrated on the foreground. I used a wet-on-wet technique for the first layer and then applied additional layers of paint, using the wet-on-dry technique. I used a straight edge to paint straight lines on elements like the edges of the roof. I used negative painting to paint around the house. Value contrasts between light and dark areas and color contrasts between the bright colors of the background and the neutral colors of the house contribute to an interesting composition. This mansion was once a status symbol in its grandiosity and now is in shambles, which, in itself, is a contrast. With this painting, I was trying to convey that the things of this world are only temporary.

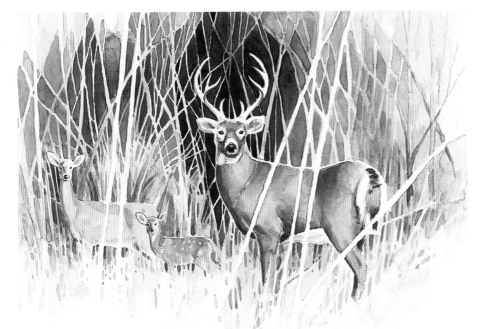

Negative Painting

I drew a structural drawing and then used my finest brushes to control my paints. Negative painting played a big role, expressing what is going on around the deer, especially the distinct forms of the tree branches that add to the composition. I used a limited palette of browns and greens, providing variation in the values of these colors to give the painting a natural feel of the outdoors. The name of this painting expresses the surprise of both the viewer and the deer, who seem to notice each other simultaneously.

Spotted
10" x 14" (25cm x 36cm)
140-lb. (300gsm) hot-press watercolor paper

Stained Glass Effect

The lead framework on stained glass usually is a dark color, but leaving it white lets the viewer concentrate on the vibrant, transparent colors, a characteristic shared by stained glass and watercolor paint.

King of Kings
7" x 4" (18cm x 10cm)
140-lb. (300gsm) hot-press watercolor paper

Living Sacrifice
7" x 4" (18cm x 10cm)
140-lb. (300gsm) hot-press watercolor paper

Let's Paint

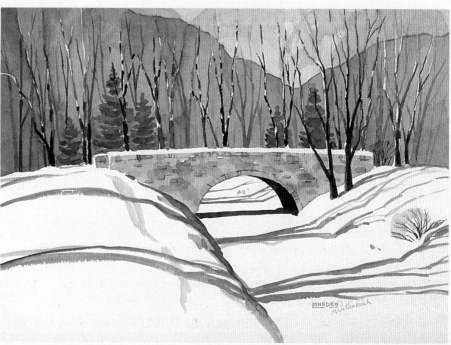

Painting with watercolors is fun, and it's even more exciting when you learn the techniques unique to this particular medium. In this chapter you'll practice some easy techniques that will bring more creativity, interest and enjoyment to your watercolor paintings and experiences.

Before each demonstration, you'll find a list of materials you'll need to complete each painting. You'll also see the image size listed. The image size is the part of the painting that will show if you mat and frame the painting. I've also listed the lessons from the book that you'll use in each demonstration. Glance back to those pages to refresh your memory before starting a painting or when you reach a trouble spot during the painting. Have fun!

Getting Ready

As we were writing this book together, we kept in mind that we were writing for you, the absolute beginner. I am a professional artist and a teacher, but teaming up with Mary, an absolute beginner herself, as a cowriter helped. Often, Mary would ask questions you might have asked if you were in one of my classes: "How did you do that?" "Why did you do this first?" "Can you talk me through this demonstration?" "Why don't my colors look like yours?" Then we tried to include answers in the book for your benefit.

Prepare Your Work Area

Make sure all of your supplies are within reach before you start painting; watercolors sometimes demand you work quickly. You'll find a comprehensive list of painting and drawing supplies on page 15. You'll also find materials specific to each painting on the first page of each demonstration. Make sure your work area is clean and dry; it's essential to a peaceful, stress-free painting session.

Prepare Your Mind

Remember to have fun with watercolors! Because they're unpredictable, some artists feel tense and out of control at first. You just have to approach watercolor painting with the appropriate mindset: Let the watercolors behave as the transparent, fluid paints they are. Let them do their thing. You may be surprised and enjoy the results.

Also keep the tips mentioned at the beginning of each demo in your mind as you paint. I'm teaching you how to paint from afar. In an actual class, I would remind you, for instance, "Remember where your light source is coming from as you lay this wash! Look for some of the whites in the painting." I can't be there to do that for you as you paint these demos, so train yourself to remember these things as you paint.

A Bit of Praise

As an instructor, I also like to comment on the positive aspects of your work as you're painting. I wish I could be there to point out the neat and unique things I can see about your painting. Encouragement is a major part of the painting process.

Don't be humble. Appreciate the successes in each painting you do. Remember that inconsistencies aren't mistakes, there will be nuances in your work. Don't forget to encourage and praise yourself. You deserve it.

Date Your Paintings

Dating your paintings will give you a creative diary of your progress. I like to go through my old paintings every once in a while, and I actually enjoy them more after they've been set aside a few months.

You may not always like a painting when you finish it. Maybe the composition didn't turn out as you planned or maybe you feel you

went too dark with the background colors. A few weeks later, though, you may find you're actually growing in your talents. Perhaps you've finally moved away from colors that are too muted. You may have trouble recognizing and appreciating growth in your own work. Keep your paintings for awhile; you may find that they grow on you.

Great Aunt Harriet

Consider matting and framing each painting. It's amazing what it can do to a simple watercolor. Although you may not always appreciate your end results, art is in the eye of the beholder. Someone else may view your painting altogether differently. Something in the composition may have special meaning to him or her, or someone like your Great Aunt Harriet may simply love it because she loves you.

Keep It Clean
Food crumbs and oils from your fingers can affect the way paint lays on your paper—so it's probably a good idea not to eat fried chicken while you paint!

Structural Drawing

In this demonstration, you'll create a structural drawing by sketching the simple shapes of a gatehouse. Take the time to draw straight, parallel lines with a straight edge.

This drawing will be the foundation for the next two watercolor demonstrations. You can either draw a structural drawing directly onto watercolor paper or draw the image on sketch paper and then trace or transfer it to watercolor paper once you're satisfied with the drawing. I prefer to draw an image on sketch paper at whatever size is comfortable. I use a photocopier to enlarge or reduce the drawing to the size I want to paint and then I transfer my drawing onto watercolor paper.

Each step in this demonstration adds basic shapes that will provide the structure for your paintings. The layered shapes will make up a complete scene.

Materials List

Paper
10" x 14" (25cm x 36cm) 140-lb. (300gsm) cold-press watercolor paper

Other
kneaded eraser
2B pencil

Lessons & Techniques

Structural drawing (page 21)
Measuring (page 22)

Tips

Take the time to create a sound drawing. It's the secret to painting a beautiful watercolor you will be proud of for years to come.

Don't worry about including too many details now. You can leave some, such as the details on the foliage, for the painting stage.

1 Draw Basic Structure of House

Draw two rectangles to create the base of the house with a 2B pencil. The bottom line should be a few inches from the bottom of your paper. Sketch a vertical dividing line through the left rectangle to help you keep things balanced.

2 Draw Roofs

Add slanted lines over the first rectangle to make a triangle that will form the peak of the roof. Divide the right rectangle horizontally to indicate the roof of this part of the house. Add a rectangle on each side of the picture, creating the wall.

3 Draw Accents
Sketch the windows, chimney and sides of the door. Draw a line to indicate where the top of the door will be.

4 Draw Curved Lines
Add the curves on the door and roof, and start detailing the windows.

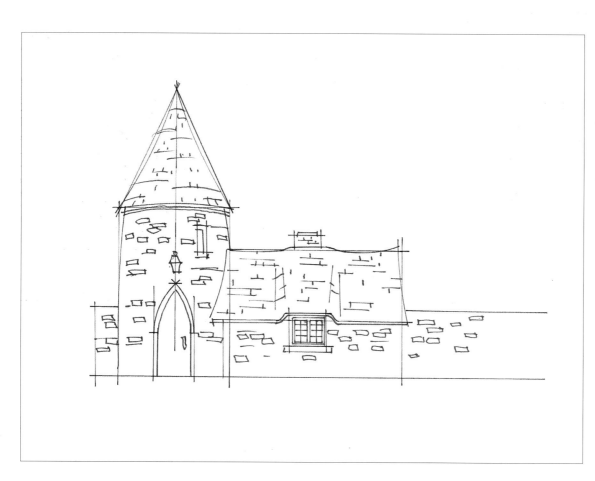

5 Add Details
Add trim details to the windows and slate roof, and draw some stones on the walls of the gatehouse.

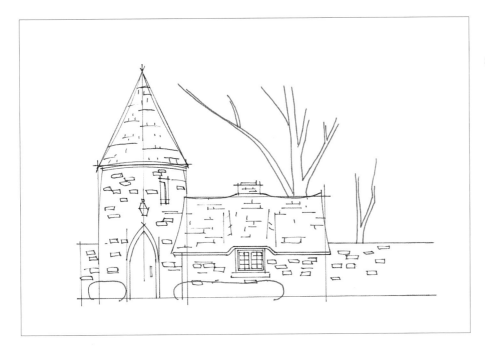

6 Draw Foliage
Indicate the basic shape of the foliage.

7 Add Finishing Touches
Finish by drawing the outline of the trees and shrubs, throwing in a few stones on the walkway and a bit of grass. You can leave the details of the foliage for your watercolors.

Now erase any unnecessary lines, such as the dividing lines that helped you draw the rooftops. On any painting, erase any unnecessary pencil lines before painting. They will be more difficult to erase once you've painted over them.

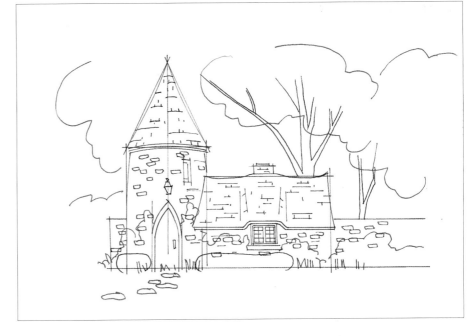

Painting With One Color

In this demonstration you'll examine the lights and darks of the scene. Concentrating on this aspect of painting, especially in watercolors, will help you master values and colors for later demonstrations. It's truly rewarding to show people a finished painting and be able to tell them that the white areas are actually the white of the paper. It shows people that you planned this painting and have the skills to follow through.

If you drew the gatehouse from the last demonstration on watercolor paper, you're ready to paint! If you drew the image on sketch paper so as not to ruin the watercolor paper with lots of erasing and redrawing, trace or transfer the image onto your watercolor paper. Unless you're using a watercolor paper block, secure all four sides of your paper to a mounting board with sealing tape.

Materials List

Paper
10" x 14" (25cm x 36cm) 140-lb. (300gsm)
 cold-press watercolor paper
Image Size for Matting and Framing
8" x 10" (20cm x 25cm)

Paint
burnt umber or sepia

Brushes
no. 2 round
no. 6 round
no. 10 round
large bamboo

Other
value scale

Lessons & Techniques

Understanding Value (page 26)
Following the Painting Process (page 38)
Mixing Paint and Handling Brushes (page 45)
Painting Wet-on-Dry (page 48)
Positive and Negative Painting (page 54)

Tips

Keep a value scale close by as you paint or even make one using the same color you're painting with. Remember that watercolor will look lighter after it dries. Don't be discouraged if a wash doesn't look like it's supposed to. Consider it a learning experience.

Let each wash dry before applying the next one. Start with general shapes and value masses and then move on to painting fine details later. Make the background darker than the gatehouse so the building's shape is clear and well defined. Keep your light source in mind as you paint. As you paint in the details, leave a bit for the imagination. Just imply texture in some places rather than painting each stone on the walls, each leaf on the trees and each blade of grass.

1 Paint Background
Paint the background leaves with a large bamboo brush. Turn the painting sideways to make it easier for you to paint around the gatehouse.

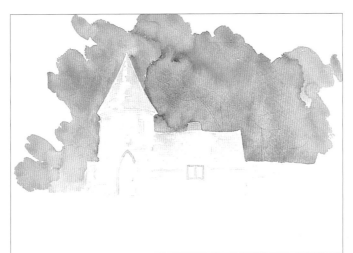

2 Paint Building
Make a mixture with a liberal amount of water to create a value lighter than the background. Add this color to the building to contrast the dark background with a no. 10 round brush. Leave some areas white to appear as highlights, paying attention to the light source shining from the upper left.

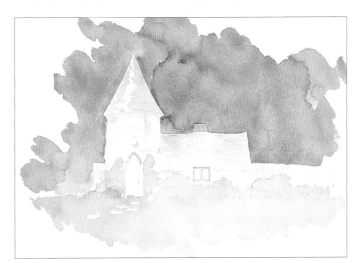

3 Paint Foreground
Make a paint mixture that is a bit darker than the building. Sweep the paint across the foreground ivy, shrubs and grass with a bamboo brush. At this point, don't worry about defining these elements; just block in the general values of the area.

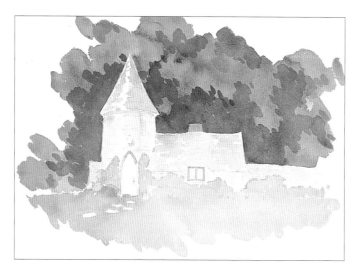

4 Add Darks to Background

The darkest value so far should be the background. Layer a darker value over some areas of the leaves with a no. 10 round brush. This will add depth to the foliage.

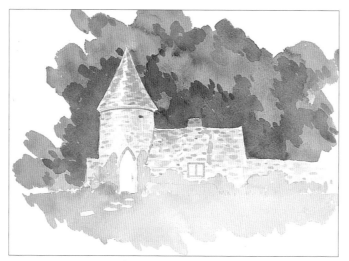

5 Add Midtones to Building

Add washes of color over several parts of the building with a no. 10 round. Make the value slightly darker than the first washes on the building.

6 Suggest Details in Foreground

Make some mixtures that are slightly darker than the first foreground wash. Apply washes of these mixtures in the foreground with a no. 10 round to suggest bushes, ivy and grass.

7 Add Another Layer of Washes

Add darker washes to the background to better define the trees and leaves with a no. 10 round. Indicate the tree trunks by painting the negative shapes around the trunks with a darker wash. Add a few dark accents to the building, including the window on the tower, the door, the eaves and some dark areas on the roof, with a no. 6 round. Remember to paint around small detail areas that will remain light, such as the handle on the door. Also add some definition to the vegetation in front of the building with a no. 6 round.

The Gatehouse
8" x 10" (20cm x 25cm)
140-lb. (300gsm) cold-press watercolor paper

8 Paint Details

Paint details on the shrubbery and roof of the building with a no. 6 round brush. Paint the smaller details on the roof, door and window with a no. 2 round. Erase any unwanted pencil lines after the painting has completely dried and then sign your name with a no. 2 round brush or a 2B pencil. If you've never signed a painting before, practice on a scrap piece of paper. If you plan to mat and frame it, keep in mind the area that will be covered by the mat board. The paper you've been painting on is 10" x 14" (25cm x 36cm). Following the table on page 63, the image area that will show after matting will be 8" x 10" (20cm x 25cm) or 9" x 12" (23cm x 30cm), depending on the size mat and frame you choose. Sign the painting within this image area and then date the painting either next to your signature or on the back of the painting.

Painting With Three Colors

This demonstration will show you just how much you can do with a limited palette. We'll use only the three primary colors to mix all of the colors represented in this scene. You'll use the structural drawing from the first demonstration as you will have worked out the values.

You'll be layering washes of different colors, just as you layered washes of different values in the last demonstration. You'll also be working on the background, building and foreground in a cycle. Allow the paint to dry before adding a new wash so paint doesn't smear or bleed into other colors. You can use a hair dryer to speed up the process, but make sure you haven't left any puddles of water, which will spread around from the force of the air. You can lift puddles with a dry brush.

Tips

Spend the extra money to buy professional grade cadmium yellow. You'll be mixing a bright yellow-green, and the student-grade cadmium yellow will not do the job. The initial background and foreground washes are mixtures of cadmium yellow and Prussian blue. As the washes get darker, add more blue. Add small amounts of alizarin crimson to the darkest washes to make the color more neutral and natural. To get a dark gray mixture, mix cadmium yellow, alizarin crimson and Prussian blue. If it looks like one color is dominant in this mixture, add a bit of that color's complementary color to make it more neutral. For example, if the mixture looks too red, add green (yellow + blue). Then dilute the mixture with water until you get the right value of gray. Keep a color wheel close by to help control and mix your colors. If you are at all unsure about the color and value of a mixture you've created, try it out on a scrap piece of watercolor paper before using it in the painting. Watercolors don't allow do-overs like other mediums do.

Materials List

Paper
10" x 14" (25cm x 36cm) 140-lb. (300gsm) cold-press watercolor paper
Image Size for Matting and Framing
8" x 10" (20cm x 25cm)

Paints
alizarin crimson
cadmium yellow (professional grade)
Prussian blue

Brushes
no. 2 round
no. 6 round
no. 10 round
large bamboo

Other
color wheel

Lessons & Techniques

Understanding Value (page 26)
Understanding Color (page 30)
Mixing Paint and Handling Brushes (page 45)
Painting Wet-on-Dry (page 48)
Positive and Negative Painting (page 54)

1 Paint Background

Make a few different yellow-green mixtures of light value from cadmium yellow and Prussian blue. Apply washes of these mixtures to the background with a bamboo brush.

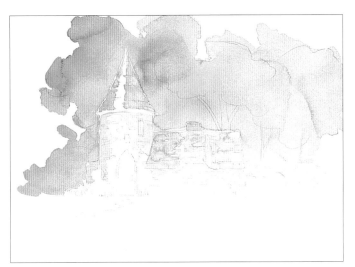

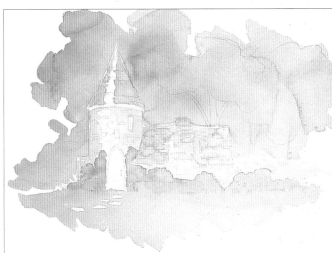

2 Paint Building

Make a few different brown and gray mixtures of light value (see the tip on page 76). Before you lay any paint down, plan which parts of the paper will be white so you can preserve the white of the paper for these areas. Refer to the monochromatic painting you just finished to help you plan. Apply washes of these mixtures for the stones, brick chimney and slate roof with a no. 10 round brush.

3 Paint Foreground

Lay down light, yellow-green washes for the foreground shapes with a bamboo brush. Add more cadmium yellow to the mixture for the grass, and add more Prussian blue for the ivy and shrubs.

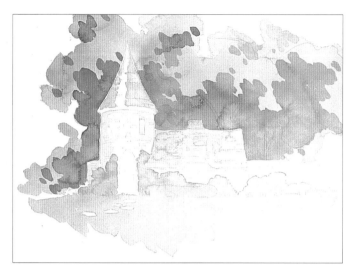

4 Add Midtones to Background

Add more Prussian blue and a small amount of alizarin crimson to your yellow-green mixture. Remembering that your light source is coming from the upper left, lay down some darker washes with a no. 10 round brush.

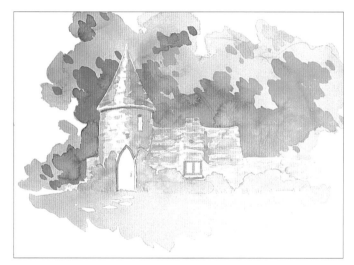

5 Add Midtones to Building

Make slightly darker brown and gray mixtures and paint over the lighter washes on the building with a no. 10 round. Leave some areas from the first layer of washes untouched. The building should now have three values; the white of the paper, the first layer of washes and some areas with the second wash layered on top of the first.

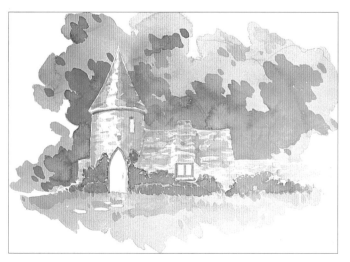

6 Add Midtones to Foreground

Darken the ivy and shrubs with more green and add some slightly darker washes of yellow-green in the grass with a no. 10 round.

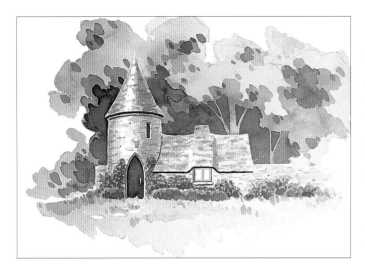

7 Add Darks

Add a few washes of a dark blue-green mixture to the background with a no. 10 round. To mix a dark blue-green, start with a regular green mixture—cadmium yellow and Prussian blue. Add small amounts of blue. Mix the color thick and rich on the palette, adding one brush full of water at a time until it is a good consistency to work with. If your paints have dried too much for you to mix them before adding water, use fresh paint.

Layer darker gray and brown washes on the building, and paint dark areas like the window, door and shadow under the eaves with a no. 6 round. Add splashes of green to the foreground with a no. 6 round.

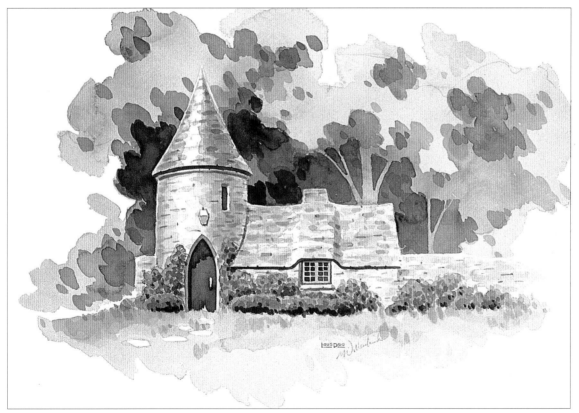

8 Add Details

Paint in the dark and light details with no. 2 and no. 6 round brushes. Erase unwanted pencil lines after the painting is completely dry. Don't forget to sign your name and date your painting!

The Gatehouse in Summer
8" x 10" (20cm x 25cm)
140-lb. (300gsm) cold-press watercolor paper

Positive Painting

Trees are beautiful to paint, and each one has its own character. A tree can add to the composition of an outdoor scene or stand alone in its own painting. This demonstration provides an easy, fun way to make graceful, interesting trees.

I chose to paint the trees void of leaves as stark silhouettes against a flaming sunset. I love to paint trees during all four seasons because each season seems to bring out a different aspect of trees. These trees are set in autumn. The analogous warm colors of the background contrast the stark, cold feeling of the tree. I also angled the wet-on-wet background strokes to add interest.

Tips

The paper will need to be wet for steps 1 through 4. Make sure you have all of your supplies at hand, and be ready to work quickly. Use a large brush to apply the wet-on-wet washes to save time. After you've finished laying down your wet-on-wet washes and the paint has dried, you'll notice that the colors have become much more muted. After gaining some experience, you'll learn to anticipate and plan for these changes. Draw the trunks of the trees first, then all the large limbs, then the medium size branches, then the smallest ones. This yields a more natural, pleasing composition. Placing the tree trunks to the side of the painting and overlapping the branches also aids the composition, creating interesting negative space and making the trees look more natural.

Materials List

Paper
12" x 16" (30cm x 41cm) 300-lb. (640gsm)
 cold-press watercolor paper
Image Size for Matting and Framing
11" x 14" (28cm x 36cm)

Paints
alizarin crimson
cadmium orange
cadmium red
cadmium yellow (professional grade)
cerulean blue
Prussian blue

Brushes
no. 2 round
no. 6 round
no. 10 round
3-inch (76mm) hake
large bamboo brush

Other
spray bottle

Lessons & Techniques

Using Analogous Colors (page 31)
Planning Composition (page 34)
Painting Wet-on-Wet (page 46)
Positive Painting (page 54)

1 Begin Background
Because you'll be painting the first four steps wet-on-wet, you'll need to work quickly before the paper or paint starts to dry. Make the following mixtures of paint and water before wetting your paper: cadmium yellow, cadmium orange, cadmium red and a purple mixture of alizarin crimson and cerulean blue.

Now wet down the paper with water from a spray bottle, and even it out with a 3-inch (76mm) hake brush so the paper is covered with an even sheen of water. Try to avoid puddles of water. Apply angled streaks of cadmium yellow with a 3-inch (76mm) hake brush.

2 Add Orange
Add cadmium orange with a 3-inch (76mm) hake brush using the same angled strokes. Once the colors have dried, notice how similar the orange and yellow appear. Colors are more vivid when the paint is wet. Keep that in mind as you paint.

3 Add Red
Add cadmium red.

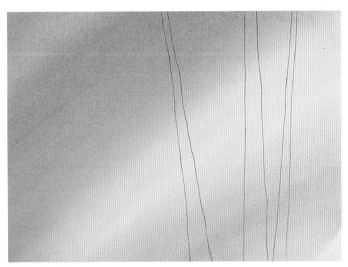

4 Add Some Interest
Add the purple color that you mixed from alizarin crimson and cerulean blue with a 3-inch (76mm) hake brush. Then sit back and take a deep breath. You've finished the wet-on-wet part of the painting.

5 Draw Trees
After the paint has dried, lightly draw the thickest parts of the trees. Sometimes it's hard to erase pencil lines after you lay a wash of paint over them, so it's easier to draw the structure of the tree over the background washes. Notice that each tree is thicker at the bottom and thinner at the top.

6 Add Limbs
Add limbs, again making sure they taper as they grow away from the trunks.

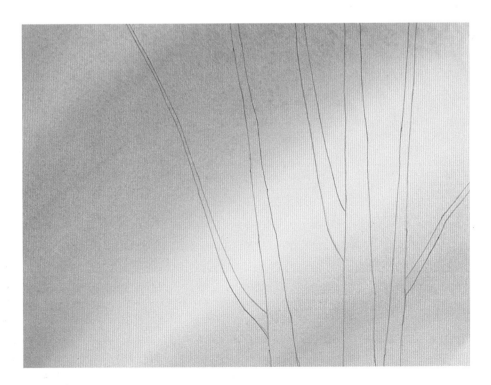

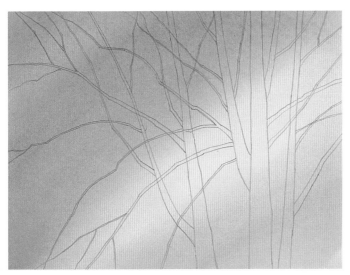

7 Finish Structural Drawing

Add the rest of the branches.

8 Paint Smallest Branches

Paint the thinnest branches with a no. 2 round and a dark mixture of Prussian blue and a slight amount of alizarin crimson.

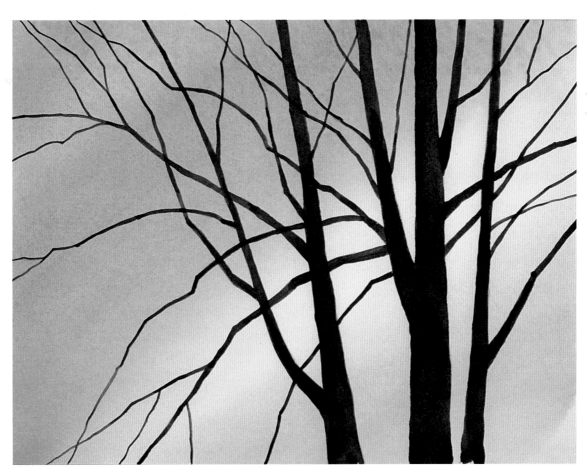

9 Finish Trees

Paint the medium size branches with a no. 6 round, the largest branches with a no. 10 round and the trunks with a bamboo brush. When the paint has dried completely, erase any visible pencil lines and sign and date the painting.

Autumn Sunset
11" x 14"
(28cm x 36cm)
300-lb. (640gsm)
cold-press watercolor
paper

Negative Painting

Painting around an object to imply its shape is a pleasant change of pace. If you enjoy doing this painting, try to incorporate negative painting into a composition of your own. Whether you use it in most of your paintings, some of them or just as a creativity exercise, negative painting enhances your composition skills and techniques. I used hot-press paper for this painting because the sharp, clean edges that result work well with the subject matter.

Remember: You don't need a bad attitude to produce a negative painting.

Tips

For a beginner, negative painting can seem intimidating and time-consuming. To make this demonstration easier, I've made the image size half the size of the positive painting demonstration. This demonstration requires detail painting. Make sure you're using brushes that form good points. Practice dropping salt into wet washes on a scrap piece of paper before trying it on your painting. Dropping salt into paint that is too dry, too wet or too thick will have little effect. Be patient; the results may be most noticeable once the paint and salt are almost dry. But don't use a hair dryer to make this part of the painting dry more quickly. It will block the salt's effect. If you're painting over another color, let the paint dry before moving on to the next step. If you're not careful, the colors will bleed and you won't have a tree anymore!

Materials List

Paper
7" x 10" (18cm x 25cm) 140-lb. (300gsm) hot-press watercolor paper
Image Size for Matting and Framing
5" x 7" (13cm x 18cm)

Paints
burnt sienna
Prussian blue
yellow ochre

Brushes
no. 2 round
no. 6 round
no. 10 round

Other
table salt

Lessons & Techniques

Structural Drawing (page 21)
Understanding Color (page 30)
Understanding Color Temperature (page 32)
Mixing Paint and Handling Brushes (page 45)
Negative Painting (page 54)
Creating Texture (page 56)

Avoid Large, Unbroken Spaces

Don't draw your trees like this. Instead, continue the branches beyond the image area. The branches on the left of this image end within the dimensions of the painting. I would have to paint the entire area on the left at once, which might leave unwanted lines if I paint over an area that already has started to dry. Instead, plan medium size, easy-to-paint areas in the drawing stage. The drawing in step 1 right provides an easier guide to follow as you lay paint down.

1 Draw Structure

Draw the trees as you did in the previous demonstration, starting with the thickest parts and moving on to the thin, tapered branches.

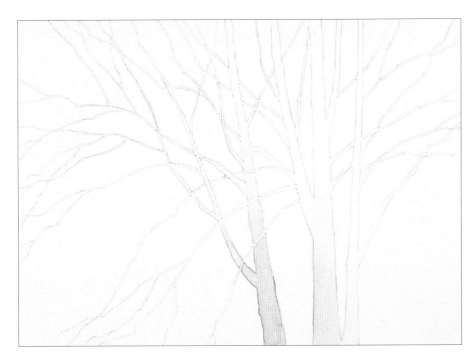

2 Paint Trees

Make separate pale mixtures of Prussian blue, burnt sienna and yellow ochre. To make a pale mixture, touch the paint with the very tip of your brush and put the paint on the palette. Add enough water to make a good size puddle. With so much water and so little paint, the mixture should be a very light value. Paint the trees with a no. 6 round, starting with blue at the bottom, fading up to a warm, light brown, then to the yellow ochre and finally to the white of the paper. The trees should be mostly white with just a bit of color.

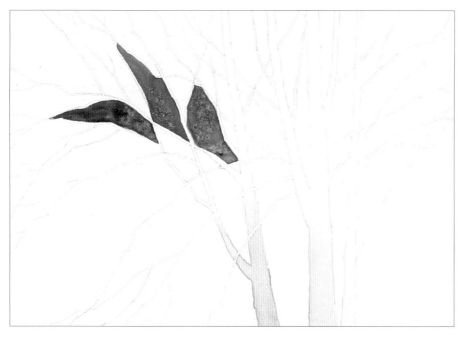

3 Begin Background and Add Salt

Make a variegated mixture of Prussian blue and burnt sienna on your palette so you can pick up a variety of these two colors as you paint. Wipe other puddles of color off your palette. Make a large, dark mixture of burnt sienna at the bottom and another large, dark mixture of Prussian blue at the top of your palette and blend the two colors in the middle. Begin to paint in the background around the trees with no. 6 and no. 10 round brushes. Because the tree trunks will draw the viewer's attention to the right, balance the composition by concentrating the strongest, contrasting values, especially the dark blue, on the left. You'll notice that the background uses darker values of the same colors used to accent the trees. After painting a few segments of the background, drop salt into the wet paint to add more texture.

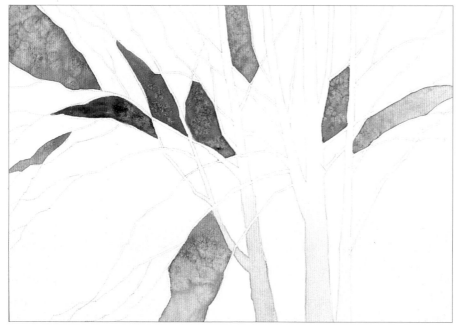

4 Add Yellow Ochre to Mix

To bring in some of the yellow from the trees, add yellow ochre to the middle of the variegated mixture on your palette and continue painting the background. Add salt as you go.

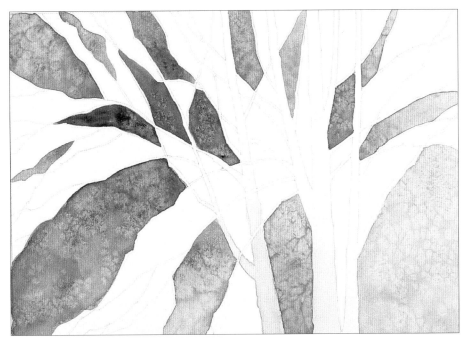

5 Don't Rush
Continue painting the background just a little at a time so you have control over the paint. Take your time adding salt to get the right effect. Don't rush yourself.

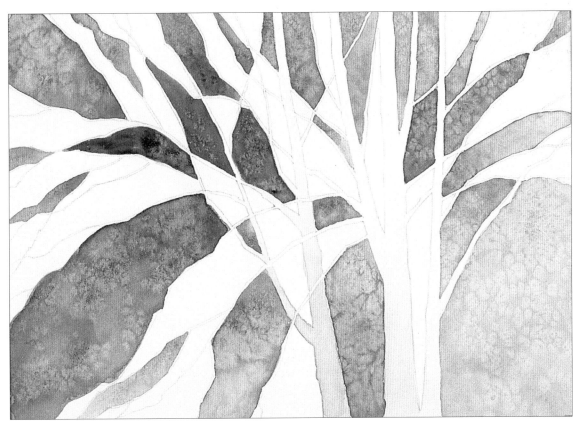

6 Continue Background
Paint a few more pieces of the background and add salt.

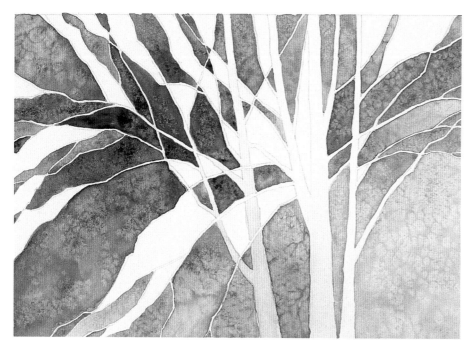

7 Paint Details
Once you've painted the bigger parts of the background, concentrate on the smaller, more detailed areas with a no. 2 round. Don't forget to keep adding salt.

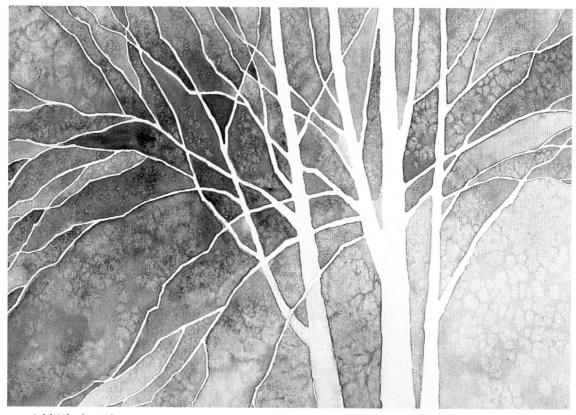

8 Add Missing Pieces
Finish painting the background with no. 2 and no. 6 rounds as if you were adding the last few pieces of a jigsaw puzzle.

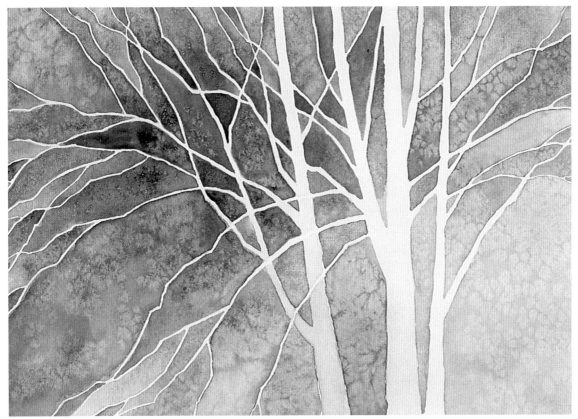

9 Finish Up

After I filled in the background and the paint dried, I stepped back to evaluate the painting. I decided to darken some of the background areas. When everything is dry, brush away the remaining salt and erase your pencil lines carefully. Sign and date your painting.

Winter Exposure
5" x 7" (13cm x 18cm)
140-lb. (300gsm) hot-press watercolor paper

Painting Flowers

You're going to get an extra drawing lesson here. You learned about linear perspective on pages 24 and 25. Perspective also applies to objects that don't have straight lines, such as the daisies in this demonstration.

To draw a circle in perspective, simply draw an ellipse. An ellipse is simply a circle viewed from an angle. Use ellipses for both the general shape of the daisy and for its center. The petals will point outward with a slight curve.

Tips

Plan your painting well during the drawing stage. Don't draw each daisy as if you were looking at it head on. Vary the perspective and tilt of each flower. Add some thickness and bulk to the flower center to keep the flower from looking flat.

Materials List

Paper
10" x 14" (25cm x 36cm) 140-lb. (300gsm)
 cold-press watercolor paper
Image Size for Matting and Framing
8" x 10" (20cm x 25cm)

Paints
alizarin crimson
cadmium orange
cadmium yellow
cerulean blue
hooker's green
Prussian blue
yellow ochre

Brushes
no. 6 round
no. 10 round

Lessons & Techniques

Structural Drawing (page 21)
Drawing Linear Perspective (page 24)
Understanding Value (page 26)
Understanding Color (page 30)
Planning Composition (page 34)
Painting Wet-on-Wet (page 46)
Painting Wet-on-Dry (page 48)
Positive and Negative Painting (page 54)

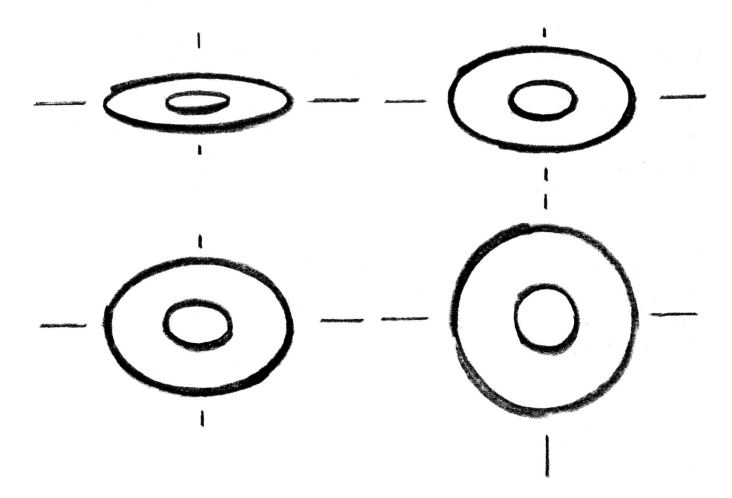

Indicating Perspective

The circles at the bottom form the base shapes of a daisy from a head-on viewpoint. The image just above represents a daisy barely leaning back. The next set of ellipses represents a daisy tilted even farther back. The daisy at the top is almost facing straight up.

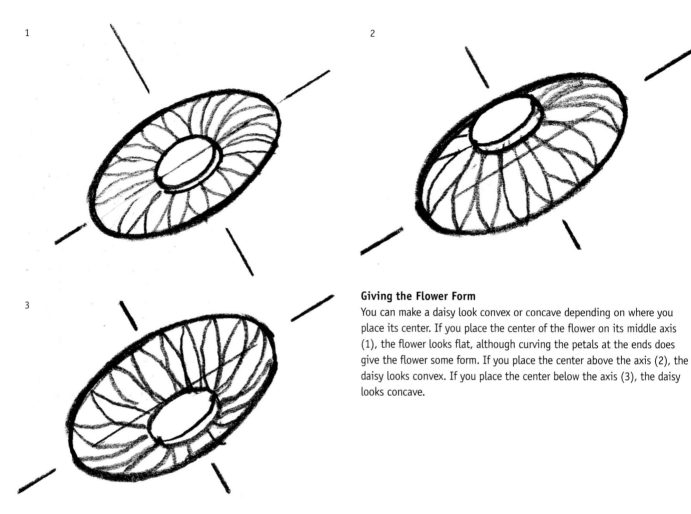

1

2

3

Giving the Flower Form

You can make a daisy look convex or concave depending on where you place its center. If you place the center of the flower on its middle axis (1), the flower looks flat, although curving the petals at the ends does give the flower some form. If you place the center above the axis (2), the daisy looks convex. If you place the center below the axis (3), the daisy looks concave.

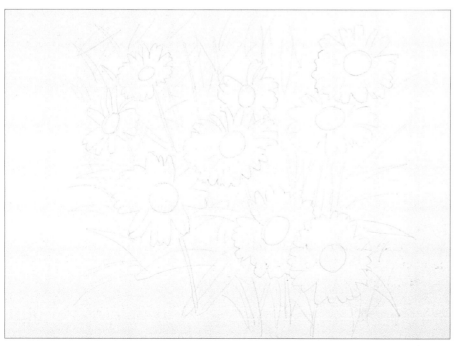

1 Draw Structure

Draw the daisies at slightly varying angles. Leave some gaps between petals to add interest and a natural feel to the scene. Just roughly draw the leaves in the background. Then erase any lines that you no longer need. Once you've got the structural drawing down, you won't need the outline of each individual petal. On your watercolor paper, you might want to make your lines a bit darker than these. I realized too late that the lines for the background leaves were difficult to see after laying down my first wash of color.

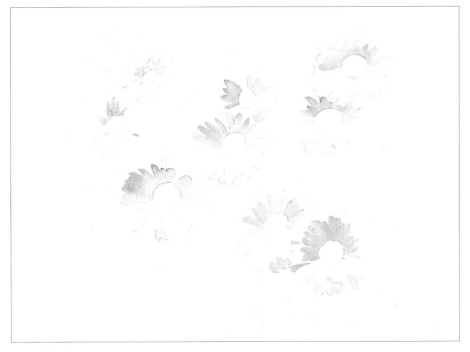

2 **Paint Shadows**
Mix alizarin crimson and cerulean blue to make purple and then add water to the mixture. Apply it to the shadow areas of the petals with a no. 10 round. While the paint is still wet, add a few touches of a mixture of yellow ochre and cerulean blue to parts of the shadow areas to add interest. The light source is shining from the upper left and slightly behind the flowers. There are also a few shadows on the bottoms of the flowers where the petals have curved down. Don't worry if the shadows look too dark. Once you paint the background, which will define the shapes of the flowers, the shadows won't appear nearly as dark. Also remember to leave the white of the paper for the white of the flowers.

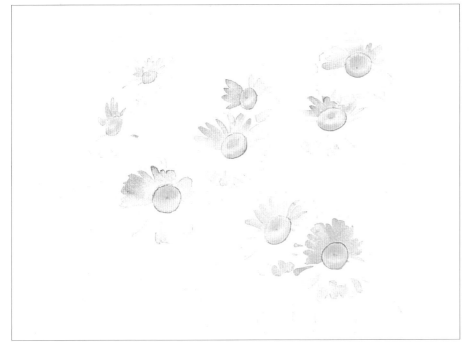

3 **Paint Centers**
Paint the flower centers with a no. 6 round brush and cadmium yellow. While the paint is still wet, drop in a small amount of cadmium orange and an even smaller amount of a mixture of cadmium orange and hooker's green in the middle and near the edge of each flower's center.

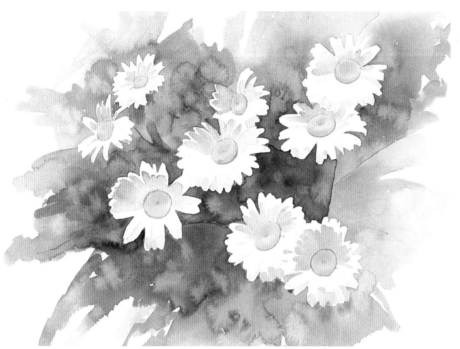

4 Paint Negative Shapes Around Daisies in Stages

Make puddles of the following mixtures or colors on your palette: hooker's green and Prussian blue; hooker's green and cadmium yellow; hooker's green and yellow ochre; cadmium orange and alizarin crimson. Paint small, manageable sections of the background with a no. 10 round, taking paint from various puddles on the palette. Notice how the daisies have taken shape and that the shadows no longer look as dark.

Painting a background this large is easier if you concentrate on small portions at a time. I painted the background in stages. Don't worry about hard edges resulting from applications of wet paint over a drying background. You'll paint over these when you add details to the background. Sometimes I even drop water onto the drying paint to add texture.

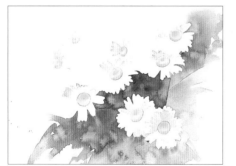

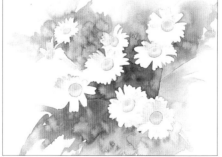

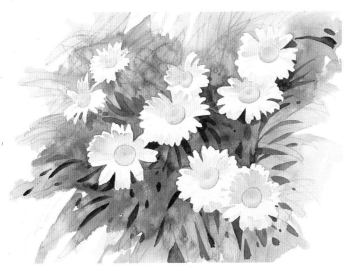

5 Define Background

Define the leaves with a no. 6 round brush and a mixture of a light amount of alizarin crimson and equal amounts of hooker's green and Prussian blue.

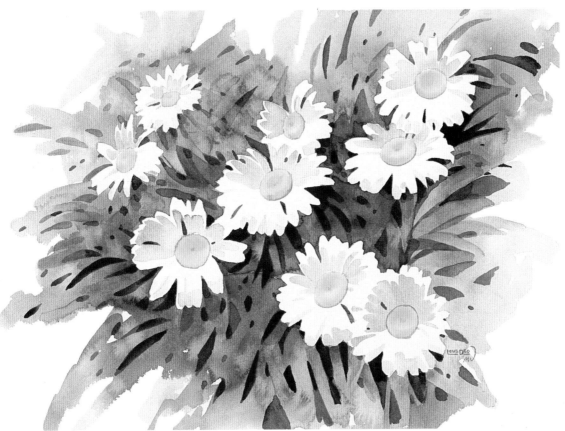

6 Finish Up

Finish the background, erase pencil lines and then sign your painting.

Shasta Parade
8" x 10" (20cm x 25cm)
140-lb. (300gsm) cold-press watercolor paper

Developing Composition

This painting's composition has three main elements, the sailboat, the house and the dinghy. The composition holds the viewer's interest because it has no elements placed directly in the center. This makes the composition seem random, though the placement of elements is actually well planned.

Tips

Review the lesson on how to paint straight lines on page 55 so you don't get frustrated; this painting has a lot of detail. If you take your time, this demonstration will reward you with a beautiful and impressive watercolor. To paint the sky, you may want to turn the picture upside down so the part you're painting is closest to you.

Materials List

Paper
10" x 14" (25cm x 36cm) 140-lb. (300gsm)
 cold-press watercolor paper
Image Size for Matting and Framing
8" x 10" (20cm x 25cm)

Paints
brown madder
hooker's green
Prussian blue
yellow ochre

Brushes
no. 2 round
no. 6 round
no. 10 round
1-inch (25mm) flat
3-inch (76mm) hake
large bamboo brush

Other
straight edge

Lessons & Techniques

Structural Drawing (page 21)
Measuring (page 22)
Understanding Value (page 26)
Painting Atmospheric Perspective (page 29)
Understanding Color (page 30)
Planning Composition (page 34)
Painting Wet-on-Dry (page 48)
Applying a Flat Wash (page 49)
Positive and Negative Painting (page 54)
Painting Straight Lines (page 55)

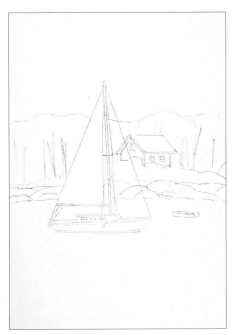

1 Draw Structure

Draw, trace or transfer the image onto watercolor paper.

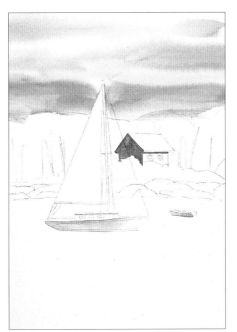

2 Paint Sky

Wet the sky and any other area that you want to be blue with clear water and a 3-inch (76mm) hake brush. Add Prussian blue to the wet areas with a 1-inch (25mm) flat. Paint the building, boat and dinghy's shadow areas with no. 6 and no. 10 round brushes and Prussian blue. The paint will spread to any area where the paper is wet, so don't wet any area you don't want to be blue.

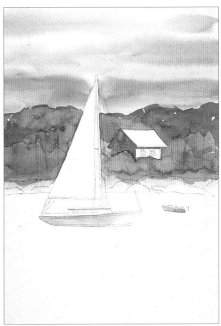

3 Paint Shore

Paint the shoreline with yellow ochre and brown madder and a no. 10 round. Add the trees with mixtures of yellow ochre, brown madder, hooker's green and Prussian blue.

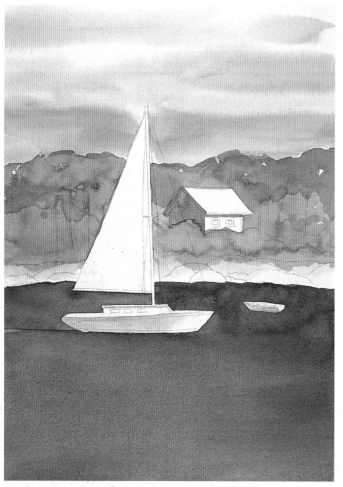

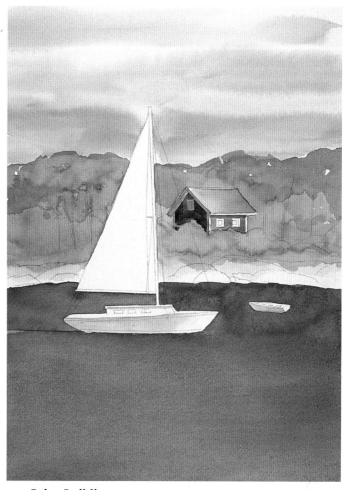

4 Paint Water

Paint the water with Prussian blue and a no. 10 round. Use a wet-on-dry technique and work quickly. Keep the edges active. Don't let the edge of a stroke dry before adding more paint and continuing to cover the water area. Start at the upper left, painting around the boat first. Then paint around the dinghy. Switch to a large bamboo brush and work across the picture from top to bottom. The point where you started painting the water probably will have started to dry, leaving a hard edge. In this part of the painting process, that's OK. It will look like wake from the sailboat, a little detail that indicates movement and makes the painting more interesting. If you accept watercolors for the way they behave, you'll come to appreciate the effects they produce and the creativity they allow.

5 Paint Building

Paint the building and the roof with a no. 6 round and a mixture of brown madder and Prussian blue, leaving the trim white.

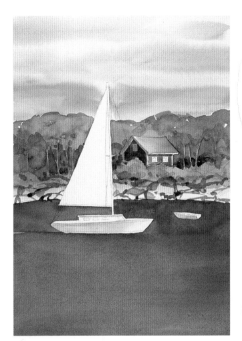

6 Add Details

Paint shadows in the trees and on the shore with a no. 10 round and mixtures of Prussian blue, brown madder, hooker's green and yellow ochre. Indicate tree trunks with negative painting using a darker mixture than the the trees in step 3.

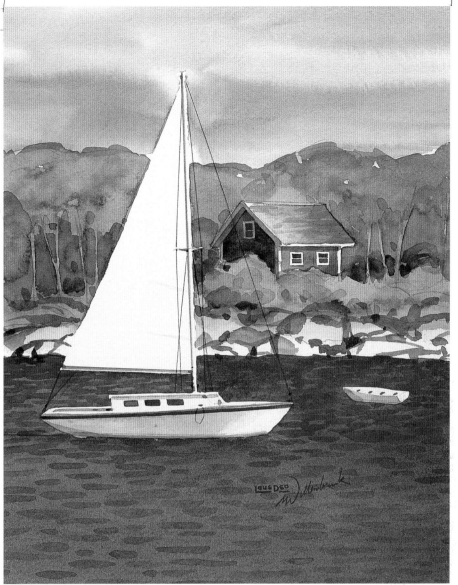

7 Paint Finishing Touches

Paint the waves with a no. 10 round and a mixture of Prussian blue and brown madder. Start with small, horizontal lines at the shore and use progressively longer, more spread out strokes as you get closer to the bottom of the picture.

Paint the windows on the building and boat with a no. 2 round and Prussian blue. Emphasize the shadow and add some accents to the roof with brown madder and the same brush. Add some accents to the dinghy. Add accents to the sailboat and sail with Prussian blue, yellow ochre and brown madder, using a straight edge and a no. 2 round to paint the straight lines. Paint the curved lines on the hull with a fluid motion by moving your arm at the elbow rather than at the wrist or fingers. Add some vague shadows on the sail with a light value of Prussian blue to indicate some wind. Sign and date the painting and you're done!

Easy Going
10" x 8" (25cm x 20cm)
140-lb. (300gsm) cold-press watercolor paper

Using a Color Scheme

Pumpkins are good subject matter to paint when learning to use water-colors because they have relatively simple shapes. As my students have learned, pumpkins may not hold the beauty of roses, but they sure are a lot easier to paint! Starting simply is a valuable part of the learning process.

Tips

Limiting your palette to just four colors and using each of these in almost each element will give your painting a feeling of continuity. Even if pumpkins are orange, that orange can have a little red, yellow and blue in it. Use all four colors to paint the two outer pumpkins. Leave Prussian blue out of the mixture for the three center pumpkins until the shading stage. Because orange and blue are complements, adding blue to the predominantly orange pumpkin will make it dull. The center pumpkins will be brighter and more noticeable to the viewer's eye. Remember to plan and preserve white space and highlights. The light source is shining from the upper right. When mixing browns, use your color chart to help get the color right. If your mixture has a bit too much of one color, add a slight amount of its complement. For example, if your brown is too green, add red.

Materials List

Paper
12" x 16" (30cm x 41cm) 300-lb. (640gsm)
 cold-press watercolor paper
Image Size for Matting and Framing
11" x 14" (28cm x 36cm)

Paints
alizarin crimson
cadmium orange
cadmium yellow
Prussian blue

Brushes
no. 6 round
no. 10 round
large bamboo brush

Lessons & Techniques

Structural Drawing (page 21)
Measuring (page 22)
Drawing Linear Perspective (page 24)
Understanding Value (page 26)
Understanding Complementary and Analo-
 gous Colors (page 31)
Understanding Color Temperature (page 32)
Planning Composition (page 34)
Following the Painting Process (page 38)
Mixing Paint and Handling Brushes (page 45)
Painting Wet-on-Wet (page 46)
Painting Wet-on-Dry (page 48)

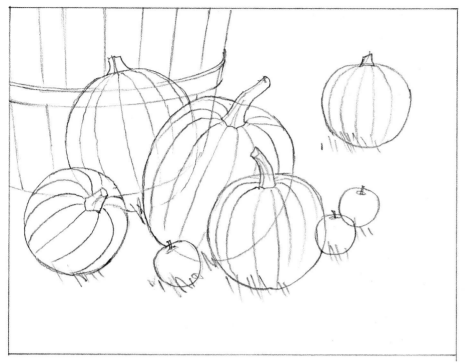

1 Draw Structure

Draw the basic shapes of your composition to work out the placement of your pumpkins. Vary the pumpkins' sizes and tilt some of them to create interest. Overlap them and make the pumpkins closest to the viewer appear lower in the scene. Even pumpkins have perspective! After adding the barrel and pumpkin stems, I decided my painting still needed a little something, so I added a few apples and some simple lines to indicate grass.

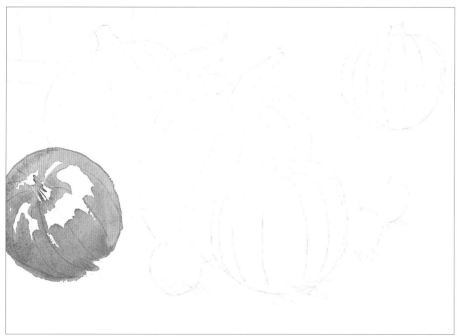

2 Begin Pumpkins

Draw or transfer the image onto watercolor paper. I changed the tilt of the pumpkin on the bottom left because I felt that it led the viewer's eye out of the painting. This small change will keep the viewer's eye within the frame of the picture. I decided to use orange and its analogous colors plus orange's complement, blue, for the color scheme.

Fill in the pumpkin on the left with a large bamboo brush and very wet, somewhat sloppy applications of cadmium orange. Painting wet-on-wet, drop in a mixture of alizarin crimson and cadmium yellow with a no. 6 round. Paint the stems with a brown mixture of alizarin crimson, cadmium orange, cadmium yellow and Prussian blue.

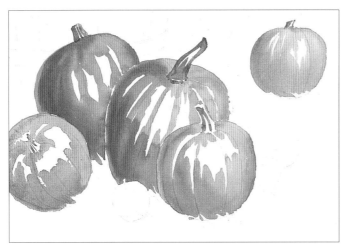

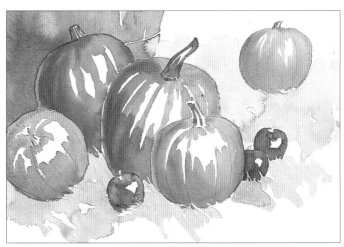

3 Continue Pumpkins

Paint the three center pumpkins with cadmium orange. Painting wet-on-wet, add some color from a mixture of alizarin crimson and cadmium yellow. Paint the pumpkin on the right the same way, adding a trace amount of Prussian blue to the mixture. Remember to preserve the white of the paper for highlights. Paint the pumpkin stems with a brown mixture of alizarin crimson, cadmium orange, cadmium yellow and Prussian blue.

4 Add Browns

Paint the barrel with a mixture of all four colors and a large bamboo brush. Paint the grass area a more neutral orange-green color with a mixture of cadmium orange, cadmium yellow, Prussian blue and just a touch of alizarin crimson. Just suggest the grass, leaving lots of white space. Paint the apples with a no. 10 round and a mixture of all four colors, using mostly alizarin crimson.

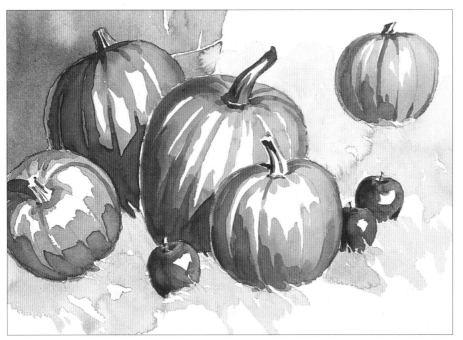

5 Add Shading

Add shading to the pumpkins to imply depth with a mixture of alizarin crimson, cadmium orange and Prussian blue and a no. 6 or no. 10 round. Add shading to the apples with a mixture of all four colors, using predominantly alizarin crimson and a little more Prussian blue than you used to paint them in step 4.

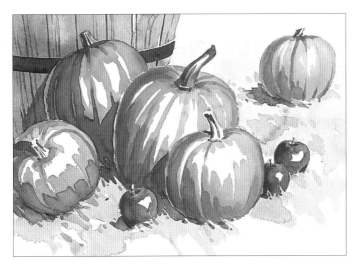

6 Add Details to Barrel

Paint the line work on the barrel with a darker brown mixture of all four colors and no. 6 and no. 10 round brushes. Add details and shading to the grass with a dark green mixture of all four colors, using mostly Prussian blue. The blue will make the green color of the grass a bit deeper, creating cool shadows.

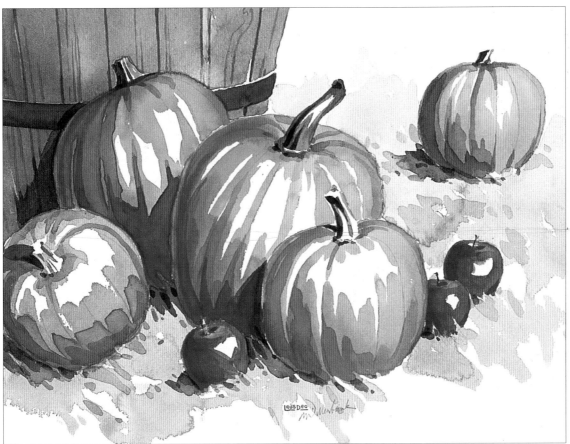

7 Add Finishing Touches

Add a darker wash over the barrel. Make the shadows on the pumpkins and apples darker with mixtures of alizarin crimson and Prussian blue. Define the shadows in the grass with a darker version of the green mixture from step 6. Erase the pencil lines and sign and date your painting.

Fall Pumpkins
11" x 14" (28cm x 36cm)
300-lb. (640gsm) cold-press watercolor paper

Painting a Landscape

It's rewarding to transform a sheet of white paper into a chilly winter scene with just a few applications of paint. Perhaps you live in an area that never sees snow. Or maybe you'll end up wanting to try this demonstration in the summertime. If so, you obviously won't be able to observe snow outside your window. When your real-life options are limited, look for reference materials in books, magazines, calendars and greeting cards to help you understand how light reflects off snow and what the shadows look like.

These reference materials will remind you that, for instance, shadows on snow usually have a blue tint, and this information will help make your painting accurate. To add to the mood and feel of the painting, heat up some hot chocolate and put on some warm slippers. Once you've finished this demonstration, try painting your own winter scenes.

Materials List

Paper
9" x 12" (23cm x 30cm) 140-lb. (300gsm)
 cold-press watercolor paper
Image Size for Matting and Framing
8" x 10" (20cm x 25cm)

Paints
brown madder
cadmium yellow
cerulean blue
Prussian blue
yellow ochre

Brushes
no. 2 round
no. 6 round
no. 10 round

Tips

Planning your white space for this painting will be even more important than for the last demonstration. You're going to use the white of your paper to represent the snow which is a large part of this scene. The only times I use cerulean blue and yellow ochre in this painting are for the shadows in the evergreen trees and for a few finishing touches. I recommend a limited palette because using every color you have whenever you feel like it will make your color composition noisy. Instead, plan your color scheme before you start painting, occasionally adding a splash or two of interesting colors, like the cerulean blue and yellow ochre in this painting.

Lessons & Techniques

Structural Drawing (page 21)
Drawing Linear Perspective (page 24)
Understanding Value (page 26)
Painting Atmospheric Perspective (page 29)
Understanding Color Temperature (page 32)
Painting Wet-on-Dry (page 48)
Applying a Variegated Wash (page 51)
Positive and Negative Painting (page 54)

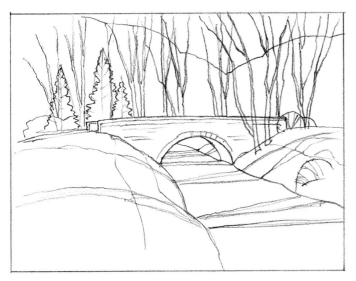

1 Draw Structure

Draw or transfer the image onto watercolor paper.

2 Paint Sky

Paint the sky with a no. 10 round and a light wash of Prussian blue. You'll paint the limbs later, but leave parts of them white now to indicate highlights and snow sitting on the branches.

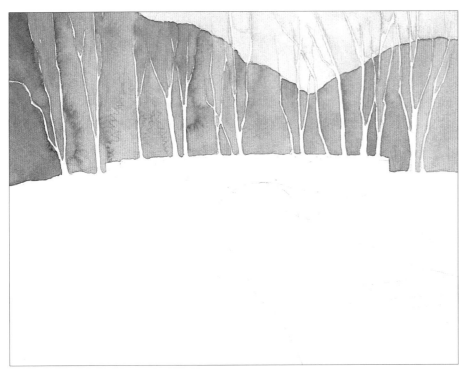

3 Paint Background

Paint the background hills with a no. 10 round and a mixture of Prussian blue and brown madder. Remember to leave the trees white.

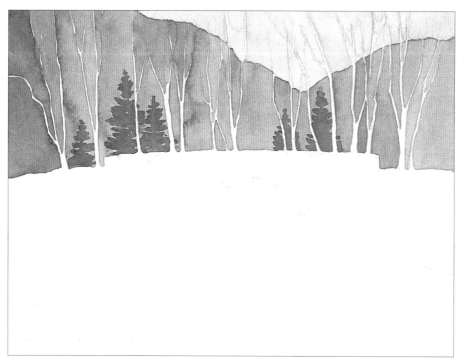

Add Interest

Paint the evergreen trees with a no. 10 round and a mixture of Prussian blue, cerulean blue, cadmium yellow and yellow ochre. I decided to add two more evergreen trees on the right to balance the painting.

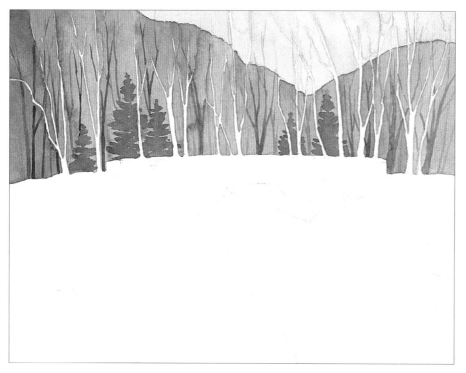

Paint Tree Trunks

Paint some extra tree trunks in the distance with no. 2 and no. 6 round brushes and a mixture of Prussian blue and brown madder. Make a relatively cool mixture that favors blue more than brown. Atmospheric perspective tells you that distant elements should be bluish gray with a neutral value, and the closer elements should have more intense color and contrast.

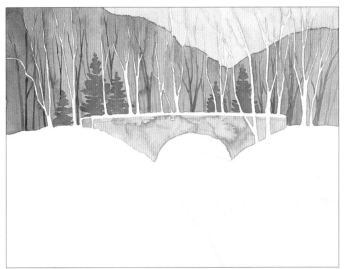

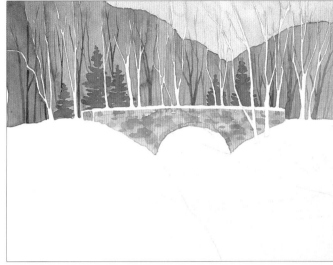

6 Paint Bridge

Apply a variegated wash of yellow ochre, brown madder and a slight amount of Prussian blue over the bridge with a no. 10 round. The bridge's color is warm, so it will appear closer than the cooler background.

7 Add Details to Bridge

Add some character to the stones of the bridge with a no. 6 round and a mixture of Prussian blue and brown madder. You can indicate texture without actually painting every stone.

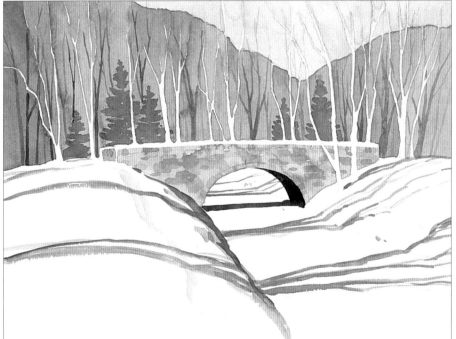

8 Paint Shadows

Paint shadows in the foreground with a no. 6 round and Prussian blue. Follow the contour lines of the snow as you paint.

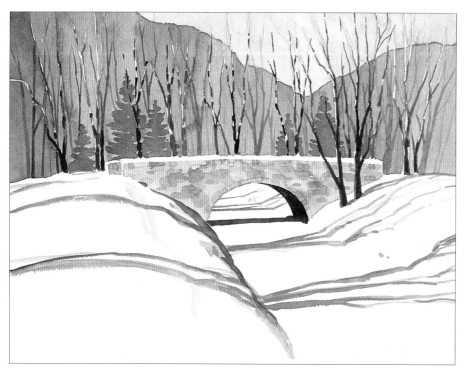

9 Paint Trees

Fill in the trees that you left white earlier. Use no. 2 and no. 6 round brushes and a mixture of Prussian blue and brown madder to paint dark, broken lines, leaving light areas to imply sunlight and snow on the branches.

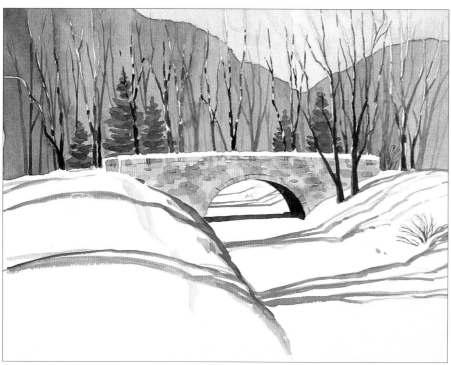

10 Add Accents

Add details to the bridge and paint the bushes with a no. 2 round and a mixture of brown madder and Prussian blue. Add shadows to the evergreens with a no. 6 round and a mixture of Prussian blue, cerulean blue, brown madder and yellow ochre.

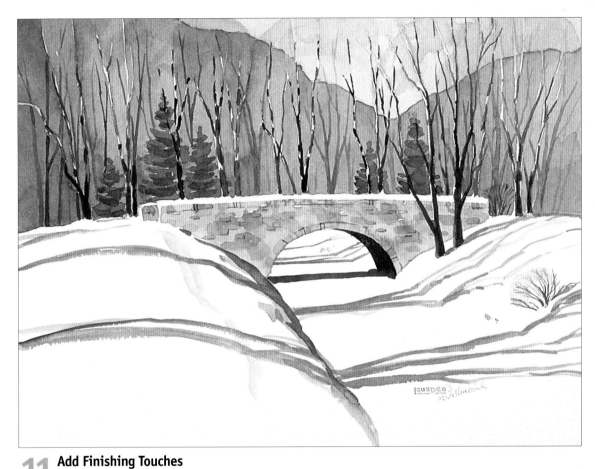

11 Add Finishing Touches

Add whatever little touches you think will bring your painting together. I added light washes of yellow ochre on some parts of the background and over the bush in the foreground. When you're happy with the painting, erase extra pencil lines and sign and date your painting.

Snowy Stony Bridge
8" x 10" (20cm x 25cm)
140-lb. (300gsm) cold-press watercolor paper

Planning a Painting

What I really like about this painting's composition is the subtlety of the cat watching the bird in the tree. The viewer really has to look at the painting to get it, and then the viewer has the pleasure of an "ah ha!" moment. The viewer really feels like he or she is sharing something with the artist. Adding little surprises to your compositions will keep your viewers on their toes.

Have fun with the challenge of painting a slightly more complicated scene. Do this demonstration more than once and see how much progress you make next time.

Tips

Do thumbnail value and color sketches before you start on the actual painting to help you decide what will work best. Then use these materials for reference as you paint. The cat is the focal point of the composition, so I especially wanted it to look good. Before starting the actual painting, spend some time on a color sketch of the cat. You'll feel much more confident going into the painting. Some paint may spill onto the window frames as you paint. To fix this you can press firmly on the area with a rag to pull up the wet paint. If the paint is still noticeable, scrape the paper with a craft knife after it dries. Scraping to correct paint spills works here because the frames will remain white. Be careful when scraping an area over which you'll apply more paint later. The area will be rough and the paint may not lay right. Don't base your success on a comparison between your results and my painting. You can look at my example for pointers and tips, but your painting doesn't have to look like mine to be interesting and successful.

Materials List

Paper
9" x 12" (23cm x 30cm) 140-lb. (300gsm) cold-press watercolor paper
Image Size for Matting and Framing
10" x 8" (25cm x 20cm)

Paints
alizarin crimson
brown madder
burnt sienna
cadmium orange
cadmium yellow
Prussian blue
yellow ochre

Brushes
no. 2 round
no. 6 round
no. 10 round
large bamboo brush

Other
craft knife
rag
salt
scraps of watercolor paper
sketch paper
straight edge

Lessons & Techniques

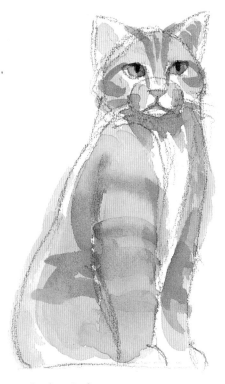

1 Gather References

Planning ahead will help answer questions that could arise while you're painting. I gather reference material from books, magazines and photographs. In this case, I looked for references of cats, birds, windows, trees and shrubs. It's extremely helpful to sketch the subject or other elements before putting them into your painting.

2 Do Preliminary Sketches

Draw small, quick thumbnail value sketches on sketch paper to work out values and your composition. I decided to use the third sketch. I like the size and arrangement of elements.

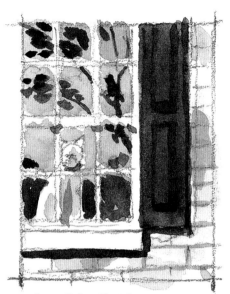 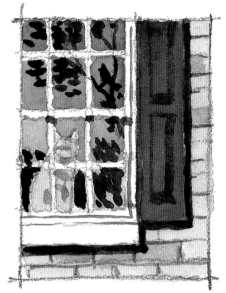 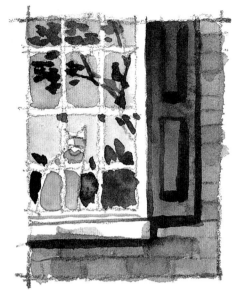

3 Draw Color Sketches

I redrew the thumbnail sketch from page 111 as a structural drawing without indicating values. Then I applied a few different color schemes, following the value pattern I had established. I like the second sketch best, though the color composition of the third is also pleasing.

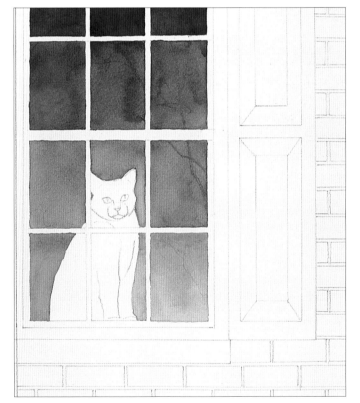

4 Paint Window Panes

Paint the window panes around the cat and window frames with a no. 10 round and Prussian blue. Make the value gradate as you move up the window. The easiest way is to lay multiple washes as you move up until each window pane is the value you want. Remember to let each wash dry completely before laying down the next one.

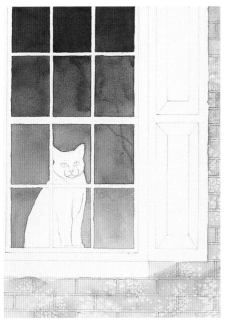

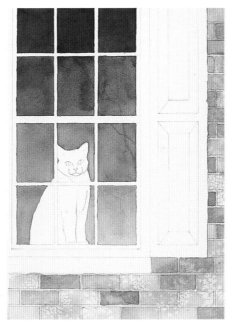

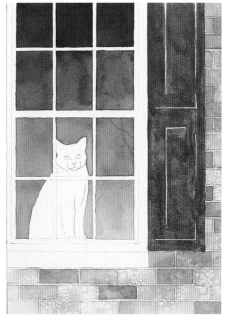

5 Paint Bricks

Lay a variegated wash of brown madder, burnt sienna, Prussian blue and yellow ochre over the bricks with a large bamboo brush. While the paint is still wet, add salt for texture. Wipe off the remaining salt after the painting has dried.

6 Add Accents

Lay second washes over individual bricks with a no. 6 round brush, taking colors from different parts of the variegated mixture from step 5 for different bricks. You don't have to paint every brick. Let some of the original wash show to provide variety. Remember to paint around the mortar between the bricks.

7 Paint Shutter

Apply a mixture of brown madder and burnt sienna over the shutter with a no. 10 round. If you want, leave some white space to indicate highlights. Make sure you paint straight lines. Paint the shutter in portions so it will seem less intimidating. A straight edge will help you paint straight lines.

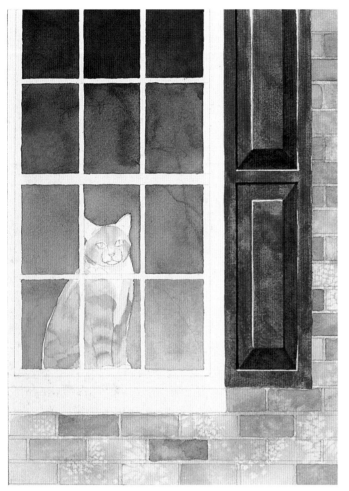

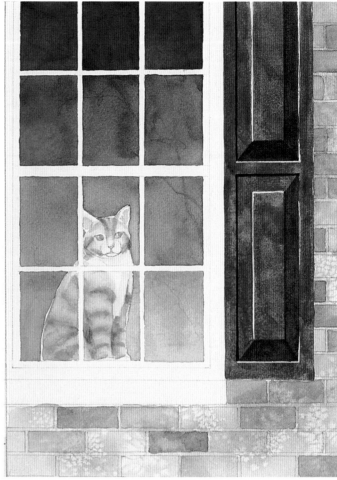

8 Paint Cat

Add shadows to the shutter with no. 2 and no. 6 rounds and a mixture of brown madder and Prussian blue. Remember that the light source is shining from the upper left. Paint the cat with a wash of yellow ochre, cadmium orange and brown madder and no. 6 and no. 10 rounds. Make sure to leave the window frames white. Apply a darker value of this mixture wet-on-wet to paint the cat's stripes.

9 Darken Stripes

Let the previous step dry. Make the cat's stripes more noticeable by applying washes of clear water followed by washes of burnt sienna, using a no. 10 round. This wet-on-wet technique will soften the edges of the stripes so they look more like fur.

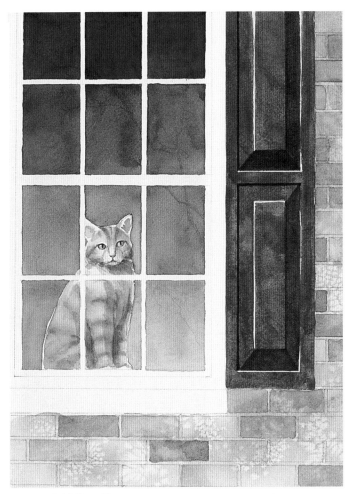

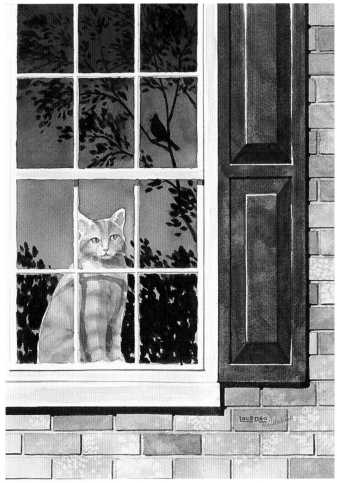

10 Add Details

Paint the cat's eyes with a mixture of yellow ochre, cadmium yellow and burnt sienna and a no. 2 round. Leave a small amount of white space to indicate highlights on the eyes. Paint the nose and mouth with a mixture of alizarin crimson and yellow ochre and a no. 2 round. Use the same mixture to paint the ears with a no. 6 round. Add shadows and define the facial features with the same colors and no. 2 and no. 6 rounds.

11 Add Silhouette

Paint the silhouette reflection on the window with a no. 6 round brush and a mixture of Prussian blue and brown madder. Start with the bird to make sure you get the proportion and placement right. Add shadows to the window frames and sill. Don't forget the shadows on the cat from the window frames. Erase extra pencil lines and sign and date another successful painting.

Window Shopping
10" x 8" (25cm x 20cm)
140-lb. (300gsm) cold-press watercolor paper

Painting a Still Life

The shapes of these objects will provide a good challenge to sharpen your drawing skills and to observe how the surfaces interact with each other, with the light source and with the shadows. You might want to find some shiny metal and glass objects to set up your own still life. Study how these objects reflect the light. The metal surface reflects the objects around it while distorting their shapes. Notice how the colors of objects behind glass come through. In the structural drawing I indicated which areas to leave untouched by paint. This kind of planning will help you paint the shine on the glass so it indicates the outline of the bottle. The matte finish of the books doesn't react with surrounding objects the same way as shiny objects, but this contrast makes the painting more interesting. I chose to paint the background with a dark color to contrast the light urn and the reflections from the glass.

Materials List

Paper
10" x 14" (25cm x 36cm) 140-lb. (300gsm) cold-press watercolor paper
Image Size for Matting and Framing
8" x 10" (20cm x 25cm)

Paints
brown madder
burnt sienna
cadmium orange
cadmium yellow
Prussian blue
yellow ochre

Brushes
no. 6 round
no. 10 round
large bamboo brush

Tips

⬤ Avoid tangents, like placing the candlestick at the side of the urn so their edges share a line. Centering the candlestick on the urn also would have looked unnatural. Instead, I placed the candlestick about a third of the way down from the edge of the urn to make a pleasing composition. ⬤ For your structural drawing, draw the highlights the same as you would draw any other object or element. This will help you preserve the white of the paper for these areas. ⬤ To enhance depth, use warm, aggressive colors in the foreground and cool, recessive colors in the background.

Lessons & Techniques

Structural Drawing (page 21)
Drawing Linear Perspective (page 24)
Understanding Value (page 26)
Painting Atmospheric Perspective (page 29)
Understanding Color Temperature (page 32)
Planning Composition (page 34)

Observe Each Object Separately
Think of the books as two simple boxes, each box with its own perspective.

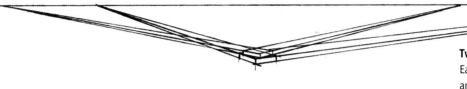

Two Two-Point Perspectives
Each book is drawn in two-point perspective, and each has its own vanishing points to make a total of four. All four still fall on the horizon.

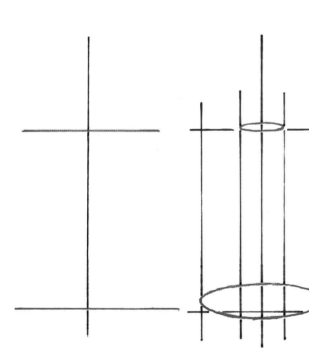

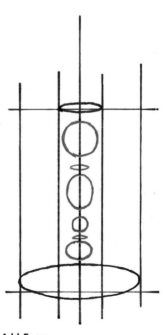

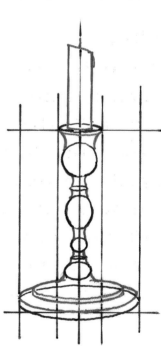

Draw Symmetrical Objects
This method for drawing a symmetrical candlestick works for all symmetrical objects. Draw a vertical line to serve as the center of your subject. Draw two horizontal lines to serve as the top and bottom of your subject.

Draw Widths
Draw two more vertical lines equidistant from the center line to denote the width of the base of the candlestick. Draw another pair of vertical lines to show the width of the top of the candlestick. Draw ellipses for the base and top of the candlestick.

Add Form
Draw circles and ovals around the center line to add form.

Finish Contour
Join the circles and ovals and add the candle to finish the drawing.

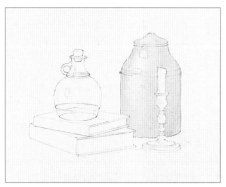

1 Paint Urn

Transfer the line drawing onto watercolor paper. Paint the urn on the right with a mixture of yellow ochre, burnt sienna, brown madder and Prussian blue and a no. 10 round. As you draw the highlights and paint around them, remember that the light source is shining from the upper left.

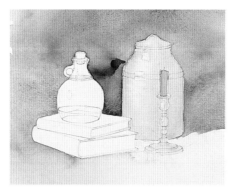

2 Paint Candlestick and Background

Paint the candlestick with a mixture of yellow ochre, cadmium yellow and cadmium orange and a no. 6 round. Add a small amount of burnt sienna to the mixture to paint the dark areas. Preserve highlight areas on the candlestick. I also left a thin white line between the candlestick and the urn to help define the candlestick's shape. Once the candlestick has dried, paint the candle with a mixture of Prussian blue and yellow ochre and a no. 6 round. I also left a thin line of white around the candle.

Paint in the background using a variegated mixture of Prussian blue, brown madder and burnt sienna. Use a large bamboo brush for the big areas and a no. 10 round for the smaller areas.

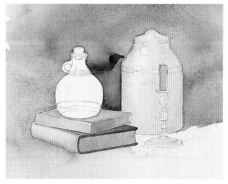

3 Paint Books

Paint the sides of the books with a no. 10 round. Paint the bottom book with a mixture of brown madder, burnt sienna and Prussian blue. Paint the top book with a mixture of yellow ochre, brown madder, burnt sienna and Prussian blue. Because the light source is coming from the upper left, the right sides of the books are in shadow, so the mixtures for these sides should be darker and cooler, with more Prussian blue. When these areas have dried, paint the covers of the books with darker versions of the same mixtures and a no. 6 round.

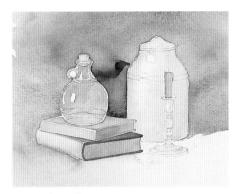

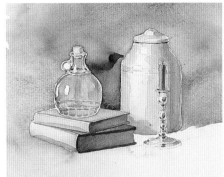

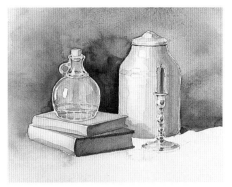

4 Paint Glass

Paint the background behind the bottle with a no. 10 round. Look for the highlights as you paint. Paint the book underneath the bottle and the cork the same color as the rest of the book with a no. 6 round. Also use this color to add the books' shadow on the urn. Leave a line of white around the edges of the bottle to help define its form.

5 Add Additional Washes

To add more detail and form, add darker washes of the original mixtures to parts of each element. Accent the urn with a no. 10 round, using a no. 6 round for the dark lines. Accent the candle, candlestick and the wick with a no. 6 round. Add accents to the books with no. 6 and no. 10 rounds. Paint details and add more washes to the bottle with a no. 6 round. Darker washes on the bottle will help the highlights stand out and make it look more like glass.

6 Add Washes to Background

Paint more washes over the background with a large bamboo brush and a no. 10 round. Darken the areas around the subject matter to create contrast.

7 Add Finishing Touches

Add the shadows of the books, glass and candlestick and add details like the dark lines underneath the urn and books to better define their shapes. Add any other washes you think you need. I needed to darken the part of the background that you can see through the bottle. Sign and date your painting and take a step back to admire it!

Relics
8" x 10" (20cm x 25cm)
140-lb. (300gsm) cold-press watercolor paper

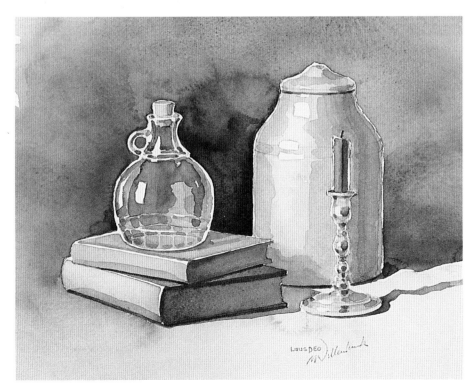

Painting a Still Life With Vegetables

The makings of a great salad are also the makings of a great still life. These subjects are easily available and fun to draw. Try getting your own vegetables and fruits and setting them up exactly as I have on page 121, putting the light source on the right. Drawing and painting from your own three-dimensional still life will teach you so much more than painting from a two-dimensional picture in a book. This demonstration also will give you insight into the difference between painting dull surfaces and painting glossy surfaces. Bon Appetit!

Tips

Again avoid tangents and make sure you draw the highlight areas in your structural drawing. I highly recommend setting up your own still life and painting from it, using the steps in this demonstration as a guide as you paint your own. The point of a still life is to observe what's in front of you, really taking the time to see what's going on with light, color and composition. Painting from your own still life will provide you with this experience much more than painting from this book can. You'll paint each vegetable with layers of washes to get the desired impact and value, so don't worry if it looks too washed out at first.

Materials List

Paper
10" x 14" (25cm x 36cm) 140-lb. (300gsm) cold-press watercolor paper
Image Size for Matting and Framing
8" x 10" (20cm x 25cm)

Paints
alizarin crimson
burnt sienna
cadmium orange
cadmium red
cadmium yellow
hooker's green
Prussian blue

Brushes
no. 6 round
no. 10 round

Other
cabbage
carrots
cauliflower
eggplant
orange pepper
red pepper
yellow pepper

Lessons & Techniques

Structural Drawing (page 21)
Understanding Color (page 30)
Planning Composition (page 34)

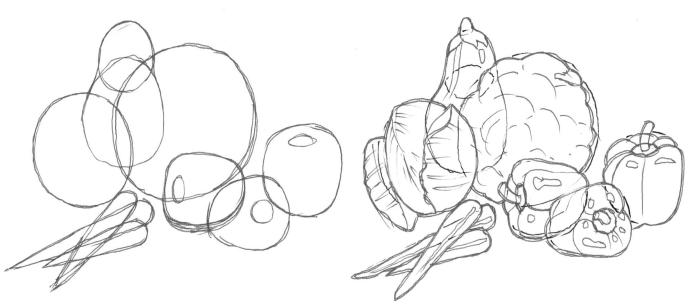

Draw in Stages

Sketch all of the basic shapes first (left) and then sketch in the details (right). Drawing in the details will include reworking a lot of the lines of the basic shapes, but starting with the basic shapes ensures a sound overall composition and accurate proportions and shapes for the vegetables.

1 Draw Structure

Draw or transfer the image onto watercolor paper.

2 Paint Yellow Pepper

Paint the yellow pepper with a predominantly yellow mixture of cadmium yellow, cadmium red and cadmium orange and a no. 10 round. Paint around the highlight areas, which are essential to communicate the glossy surface of the pepper.

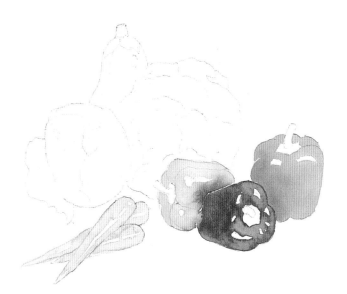

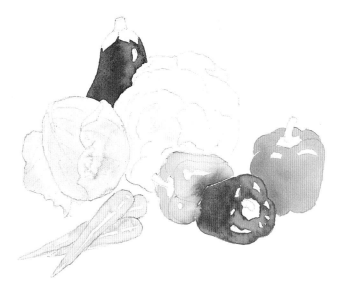

3 Paint Reds and Oranges

Paint the red pepper with a mixture of alizarin crimson, cadmium red and cadmium orange. Leave just a hairline of white between the yellow and red peppers. If the paint of both is still wet, the colors will bleed into each other a bit. This effect only occurs in watercolors, and it's one of the qualities that makes the medium so popular and fun to work with. When the painting is finished, the bleed will look like a red reflection on the yellow pepper.

Paint the orange pepper and carrots with a mixture of cadmium red and cadmium orange and a no. 10 round. Paint both with the same mixture, simply watering down the mixture to make a lighter value for the carrots.

4 Paint Remaining Vegetables

Paint the cauliflower with a mixture of cadmium yellow and slight amounts of hooker's green and burnt sienna and a no. 10 round. Follow its contours with your brushstrokes, leaving highlight areas untouched. Paint the cabbage with a mixture of hooker's green, cadmium yellow and a slight amount of alizarin crimson. The surface of cabbage isn't glossy, so I didn't leave any highlights. The cauliflower was still wet when I painted the cabbage, so I let the green bleed into the cauliflower. The color will make a good shadow on the cauliflower. When the cabbage and cauliflower dry, paint the eggplant with a deep purple mixture of alizarin crimson, Prussian blue and a slight amount of hooker's green.

5 Add Greens

When the paint from step 4 dries, use no. 6 and no. 10 round brushes to paint washes of green over the stems and greenery with a mixture of hooker's green, cadmium yellow and a slight amount of alizarin crimson. While you're working with this green mixture, add some washes to the cabbage.

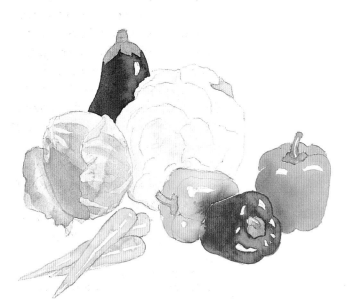

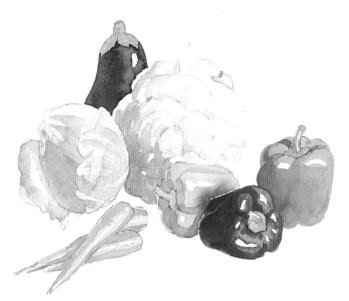

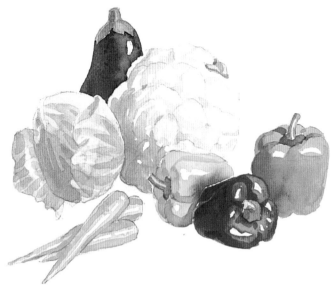

6 Add More Color

Paint additional washes on the carrots and orange and yellow peppers with a mixture of alizarin crimson, cadmium red, cadmium orange, cadmium yellow and some Prussian blue to darken it. Paint the darkest parts of the red pepper with a mixture of alizarin crimson and Prussian blue. When the cabbage and yellow pepper dry, paint the shadow on the cauliflower with a no. 10 round and a mixture of hooker's green, Prussian blue and alizarin crimson.

7 Shade Greens

Add more washes of green over the cabbage and the greenery on the other vegetables with a no. 10 round and a mixture of hooker's green, Prussian blue, alizarin crimson and cadmium yellow.

8 Add Shading

Add shadows on and under each vegetable, especially on the green areas with a mixture of Prussian blue, alizarin crimson and hooker's green. Add some shading on the eggplant with the same mixture. Use a lighter value of this mixture to define the cabbage's shadow on the cauliflower. At this point I considered adding color to the background to define the shape of the cauliflower. Instead, I added a small leaf on its lower right to frame it. This detail and the similar color of the shadows and the eggplant really help bring the composition together. Sign and date your last painting.

Fresh Produce
8" x 10" (20cm x 25cm)
140-lb. (300gsm) cold-press watercolor paper

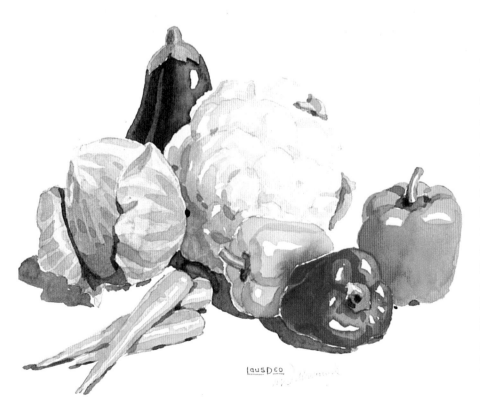

Glossary

Aggressive Colors warm colors that appear to come forward visually

Analogous Colors a range of colors adjacent to each other on the color wheel: blue-green, blue, blue-violet and violet, for example

Atmospheric Perspective depth implied through value and color temperature

Back Run an instance in which paint at the edge of a freshly applied wash runs back into the wash area, which has begun to dry, creating a watermark; you can avoid back runs by pulling up any extra paint and water with a dry brush before it flows back into the wash

Bamboo Brush a paintbrush with a round handle made from bamboo; when wet, the coarse hairs should taper to a point

Block a pad of watercolor paper in which the sheets are glued together on all four sides so the paper will wrinkle less when made wet; you can remove the top sheet after the painting has dried by inserting a knife between the top two sheets and running it around the four sides

Cake a hard, dry version of watercolor pigment

Chroma color or color intensity

Cold-Press Watercolor Paper paper that has a moderately rough surface texture

Color Mixing mixing one or more paint colors with water to achieve the desired transparency, color and value

Color Scheme a family of colors used together in a painting, also referred to as a painting's palette

Color Sketch a small, quick, preliminary painting used to plan the colors of a composition

Color Theory principles of how colors relate to one another

Color Wheel a circular chart showing the primary, secondary and tertiary colors and how they relate to one another

Complementary Colors two colors that appear opposite each other on the color wheel, red and green, for example

Composition an arrangement of elements, including structure, value and color, that provides a path for the eye to follow through the painting

Contrast the existence of extreme differences between specific elements of a painting, most commonly used to discuss value

Cool Colors colors that look cool, such as green, blue and violet, also referred to as recessive colors

Crop expose or display only part of a painting, photograph or scene

Drybrush a term to describe an application of paint to a dry surface using a brush loaded with paint and very little water

Ellipse a circle placed at an angle to show perspective

Flat Brush a paintbrush with bristles that form a wide, flat edge, as opposed to a round brush with bristles that form a point

Flat Wash a wash of paint and water that is even in value and color

Focal Point the area or part of a painting to which the composition leads the eye, also referred to as the center of interest

Foreshorten to give the appearance of depth and projection by shortening the visible area of an element; imagine a door and doorway. When the door is closed, the door is the same width as the doorway. As you open the door, the apparent width of the door becomes less wide compared to the door frame

Gradate to create a transition from one value or color to another

Gradated Wash a wash that changes value

Grade the quality of materials, such as professional grade or student grade

Hake Brush (pronounced hockey) a wide, flat paintbrush with coarse hairs and a paddle-shaped, wooden handle

Hard Edge the sharply defined edge of a wash or stroke of paint that dried without its edges being blended

Highlight an area of reflected light on an object

Horizon Line the line where land or water meet the sky, in reference to linear perspective

Hot-Press Watercolor Paper paper that has a smooth surface texture

Imprint to create texture by pressing an item, such as a sponge, loaded with paint against a painting surface

Intensity the potency or strength of a color

Kneaded Eraser a soft, pliable gray eraser that damages watercolor paper less than other erasers because it's less abrasive and doesn't crumble

Lead the graphite in a pencil and also the scale that rates the hardness or softness of the graphite: 6B, 5B, 4B, 3B, 2B, B, HB, H, 2H, 3H, 4H, 5H and 6H from soft to hard

Leading Lines a group of compositional elements used to form lines to direct the viewer's eye to points of interest

Lightfastness the degree to which a paint resists fading

Light Source the origin of the light shining on elements in a composition

Linear Perspective depth implied through line and the relative size of elements in a painting

Measure to determine specific proportions of elements in a scene

Mixture a combination of watercolor paint and water

Mop Quil Brush a round paintbrush with soft hairs that form a point when wet, known for holding lots of fluid

Monochromatic painting a painting done with different values of one color

Natural Hair Brush a paintbrush made of natural animal hairs

Negative Painting painting around shapes or elements to imply their forms

Neutral Colors browns and grays made from combinations of the three primary colors

One-Point Perspective a type of linear perspective with one vanishing point

Pad a stack of sheets of watercolor paper attached at one side with glue or wire

Paper Weight the thickness of a sheet of paper; common weights are the thin 90-lb. (190gsm), the moderate 140-lb. (300gsm) and the thick 300-lb. (640gsm)

Plein Air a french term meaning "open air," used to describe painting on site

Positive Painting painting an element against a lighter background, as opposed to negative painting

Primary Colors the three basic colors—red, yellow and blue—from which all other colors are derived

Recessive Colors cool colors that appear to recede visually

Reflected Light light reflected off one element onto another

Rough Watercolor Paper paper that has a rough surface texture

Round Brush a paintbrush that has fine, stiff bristles that come to a point, as opposed to a flat brush with bristles that form an edge

Scrub to move a brush back and forth over a wash to remove some of the paint; this technique can damage both the brush and the paper's surface

Secondary Colors the three colors made from a combination of two primary colors: orange, green and violet

Soft Edge the edge of a wash that has been smoothly blended into the surrounding area

Solubility the degree to which paint dissolves and mixes with water

Spatter to create texture by applying random dots of paint

Stencil to create texture by covering parts of the surface with a patterned material, such as an onion bag, and applying paint over it

Stretch to attach wet paper to a board so it won't wrinkle as it dries

Structural Drawing a drawing of the shapes and forms in a scene without value or color

Synthetic Hair Brush a paintbrush made with artificial bristles

Tangent the point at which two compositional elements touch or intersect; tangents usually detract from a composition.

Tertiary Colors the colors made from combinations of one primary color and one secondary color: blue-violet, for example

Thumbnail Sketch a small, quick sketch used to plan a composition

Transfer Sheet a sheet of tracing paper covered with graphite on one side, used to transfer an image onto your painting surface

Tube a container of soft, moist watercolor paint

Two-Point Perspective a type of linear perspective with two vanishing points

Value the lightness or darkness of a color

Value Scale a scale showing the range of values of a color

Value Sketch a pencil sketch used to plan the lights and darks of a painting

Vanishing Point a point on the horizon line at which parallel lines seem to converge

Variegated Wash a wash that changes color

Viewfinder a device used to crop a scene

Warm Colors colors that look warm, such as red, orange, and yellow, also referred to as aggressive colors

Wash an application of a paint and water mixture

Wet-on-Dry a term to describe an application of paint to a dry surface using a brush loaded with paint and a normal amount of water

Wet-on-Wet a term to describe an application of paint to a wet surface using a brush loaded with paint and a normal amount of water

Index

Explore Watercolor with North Light Books

Packed with insights, tips and advice, *Watercolor Wisdom* is a virtual master class in watercolor painting. Jo Taylor illustrates every important technique with examples, sketches and demonstrations, covering everything from brush selection and composition to color mixing and light. You'll learn how to find your personal style, work emotion into your work, understand and create abstract art and more.

ISBN 1-58180-240-4, hardcover, 176 pages, #32018-K

No matter how little free time you have available for painting, this book gives you the confidence and skills to make the most of every second. Learn how to create simple finished paintings within sixty minutes. Then attack more complex images by breaking them down into series of "bite-sized" one-hour sessions. Includes 12 step-by-step demos!

ISBN 1-58180-035-5, paperback, 128 pages, #31800-K

Here's all the instruction you need to create beautiful, luminous paintings by layering with watercolor. Linda Stevens Moyer provides straightforward techniques, step-by-step mini-demos and must-have advice on color theory and the basics of painting ight and texture— the individual parts that make up the "language of light."

ISBN 1-58180-189-0, hardcover, 128 pages, #31961-K

Combine your passions for travel and painting by creating beautiful watercolor sketchbooks of your trips, capturing the places, people and events you never want to forget. Inside you'll find easy-to-use techniques for painting a sketchbook on the road—one you'll want to keep and show your family and friends.

ISBN 1-58180-272-2, hardcover, 128 pages, #32143-K

These books and other fine North Light titles are available from your local art & craft retailer, bookstore, online supplier or by calling 1-800-448-0915.